Photographs by Ken Duncan: Front cover, Foreword facing page, 42-43, 60-61, 66-67, 74-75, 86-87, 91, 104-105, 138-139, 140-141 panoramic, 142-143 panoramic, 143 bottom inset.
Photographs by Philippe Antonello: Title page, 3-41, 46-57, 62-65, 68-73, 76-85, 88-90, 92-103, 106-136, 140-141 insets, 143 top inset.

Creative Director: Jim Bolton
Designed by Gloria Chantell
Edited by Bonne Steffen

Aramaic and Latin text with English translation taken from *The Passion of The Christ*, a screenplay by Benedict Fitzgerald and Mel Gibson. Copyright © 2004 by Icon Distribution, Inc.

Scripture selections are taken from the Douay-Rheims Bible, the classic Catholic English-language Bible translated in 1582 and 1609 from the Latin Vulgate Bible of St. Jerome (342-420) and revised by Bishop Richard Challoner c. 1750.

ISBN: 0-89555-781-9
Catholic Edition published by TAN Books and Publishers, Inc., P.O. Box 424, Rockford, Illinois 61105. www.tanbooks.com

08 07 06 05 04
6 5 4 3

Printed in the United States of America

THE PASSION

PHOTOGRAPHY FROM THE MOVIE

THE PASSION OF THE CHRIST

People often ask me why I wanted to make a film about the Passion of Our Lord. My usual response is that I've wanted to make this film for over ten years, which is true. That seems to answer the question for most.

The reality, of course, is more complex, and had its genesis during a time in which I found myself trapped with feelings of terrible, isolated emptiness. Because I was brought up to be a good Christian and a good Catholic, the only effective resource for me was prayer. I asked God for His help.

It was during this period of meditation and prayer that I first conceived the idea of making a film about The Passion. The idea took root very gradually. I began to look at the work of some of the great artists who had drawn inspiration from the same story. Caravaggio immediately came to mind, as well as Mantegna, Masaccio, Piero della Francesca . . . their paintings were as true to their inspiration as I wanted the film to be of mine. It is one thing to paint one moment of The Passion and be true to it; it is quite another to dramatize the entire mysterious event.

Holy Scripture and accepted visions of The Passion were the only possible texts I could draw from to fashion a dramatic film. But what about the film itself? I wanted the effort to be a testament to the infinite love of Jesus the Christ, which has saved, and continues to save, many the world over.

There is a classical Greek word which best defines what "truth" guided my work, and that of everyone else involved in the project: *alētheia*. It simply means "unforgetting" (derived from *lēthē*—water from Homer's River Lethe caused forgetfulness). It has unfortunately become part of the ritual of our modern secular existence to forget. The film, in this sense, is not meant as a historical documentary nor does it claim to have assembled all the facts. But it does enumerate those described in relevant Holy Scripture. It is not merely representative or merely expressive. I think of it as contemplative in the sense that one is compelled to remember (unforget) in a spiritual way which cannot be articulated, only experienced.

That is the truth I aspired to, as did my friends Philippe Antonello and Ken Duncan, both of whom were often on hand during the filming. Their keen-eyed way of looking and seeing fills this book. The images that move rapidly in the film move more slowly in these photographs, but pull you into the moments they depict. They are, in their own right, pieces of a larger revelation. My new hope is that *The Passion of The Christ* will help many more people recognize the power of His love and let Him help them to save their own lives.

Los Angeles, October 2003

THE PASSION

GETHSEMANE

Then Jesus came with them into a country place which is called Gethsemane, and he said to his disciples: "Sit you here till I go yonder and pray." And taking with him Peter and the two sons of Zebedee, he began to grow sorrowful and to be sad. Then he saith to them: "My soul is sorrowful even unto death: stay you here and watch with me."

And going a little farther, he fell upon his face, praying, and saying: "My Father, if it be possible, let this chalice pass from me. Nevertheless, not as I will, but as thou *wilt*." And he cometh to his disciples, and findeth them asleep, and he saith to Peter: "What? Could you not watch one hour with me? Watch ye and pray, that ye enter not into temptation. The spirit indeed is willing, but the flesh is weak."

Again the second time, he went and prayed, saying: "My Father, if this chalice may not pass away, but I must drink it, thy will be done." And he cometh again and findeth them sleeping, for their eyes were heavy.

And leaving them, he went again; and he prayed the third time, saying the selfsame word. Then he cometh to his disciples and saith to them: "Sleep ye now and take your rest; behold the hour is at hand, and the Son of man shall be betrayed into the hands of sinners. Rise, let us go, behold he is at hand that will betray me."

JESUS IS BETRAYED

Judas therefore, having received a band of soldiers and servants from the chief priests and the Pharisees, cometh thither with lanterns and torches and weapons.

Jesus therefore, knowing all things that should come upon him, went forth and said to them: "Whom seek ye?"

They answered him: "Jesus of Nazareth."

Jesus saith to them: "I am he." And Judas also, who betrayed him, stood with them. As soon therefore as he had said to them: "I am he," they went backward and fell to the ground.

Again, therefore, he asked them: "Whom seek ye?" And they said, "Jesus of Nazareth."

Jesus answered, "I have told you that I am he. If therefore you seek me, let these go their way."

And he that betrayed him had given them a sign, saying: "Whomsoever I shall kiss, that is he; lay hold on him, and lead him away carefully." And when he was come, immediately going up to him, he saith: "Hail, Rabbi"; and he kissed him.

And Jesus said to him: "Friend, whereto art thou come?" Then they came up, and laid hands on Jesus, and held him. And behold one of them that were with Jesus, stretching forth his hand, drew out his sword, and striking the servant of the high priest, cut off his ear.

Then Jesus saith to him: "Put up again thy sword into its place, for all that take the sword shall perish with the sword.

Thinkest thou that I cannot ask my Father, and he will give me presently more than twelve legions of angels? How then shall the scriptures be fulfilled, that so it must be done?" And when he had touched his ear, he healed him.

And Jesus said to the chief priests and magistrates of the temple, and the ancients that were come unto him: "Are ye come out, as it were against a thief, with swords and clubs? When I was daily with you in the temple, you did not stretch forth your hands against me: but this is your hour, and the power of darkness." Then the disciples all leaving him, fled.

And a certain young man followed him, having a linen cloth cast about his naked body; and they laid hold on him. But he, casting off the linen cloth, fled from them naked.

Matthew 26:36–46, 49–54, 56; John 18:3–8; Mark 14:44, 51–52; Luke 22:51–53

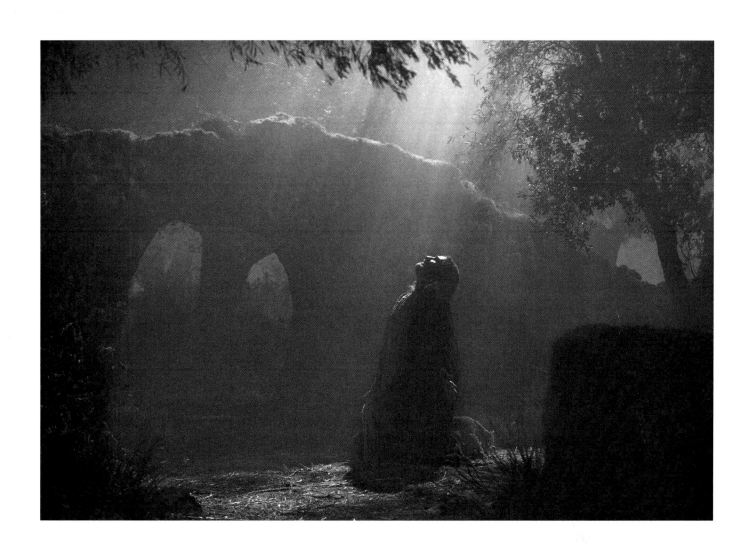

"My Father, if it be possible, let this chalice pass from me.
Nevertheless not as I will, but as thou wilt."

Matthew 26:39

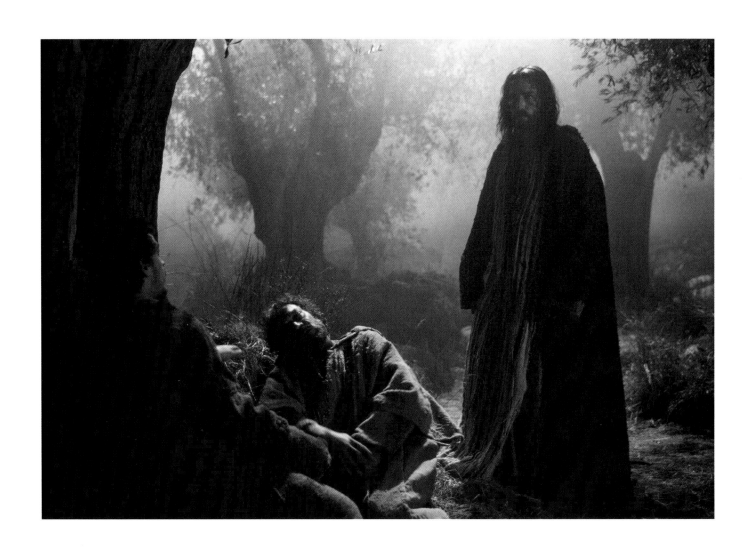

"Could you not watch one hour with me?"

Matthew 26:40

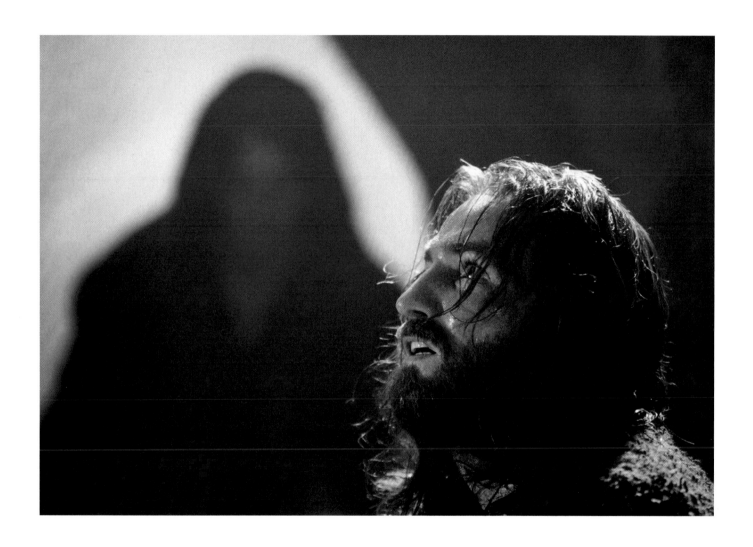

Again the second time, he went and prayed, saying: "My Father, if
this chalice may not pass away, but I must drink it, thy will be done."

Matthew 26:42

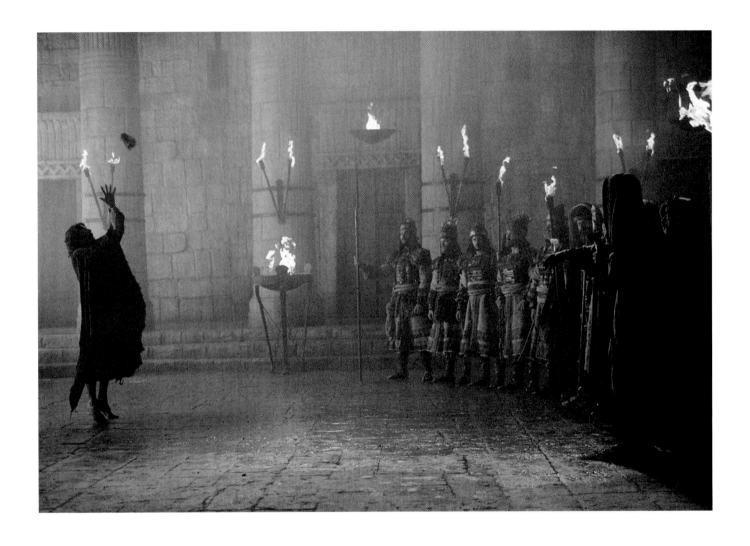

. . . the thirty pieces of silver, the price of him that was
prized, whom they prized of the children of Israel.

Matthew 27:9

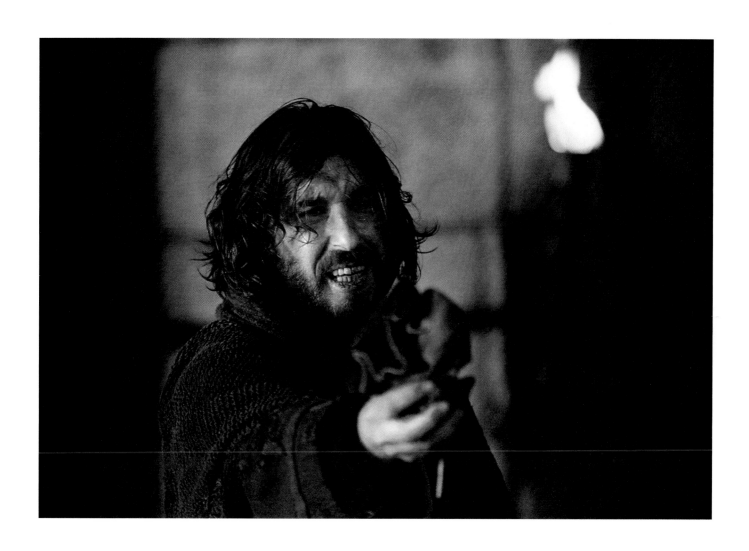

But they appointed him thirty pieces of silver.

Matthew 26:15

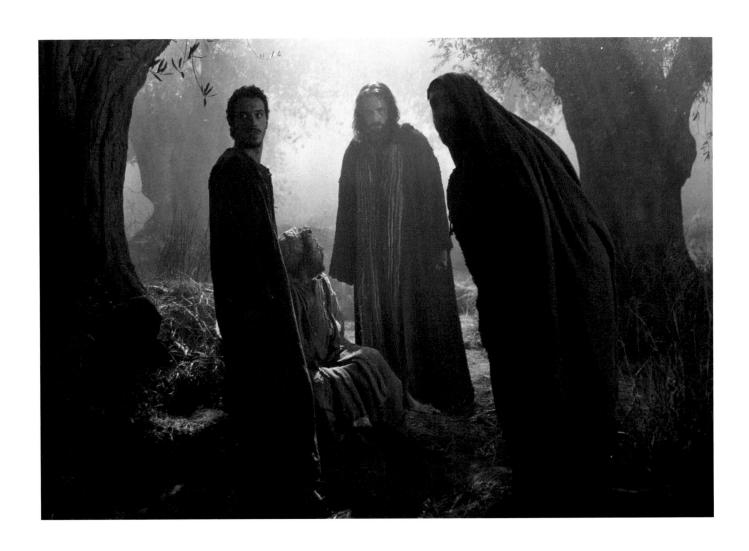

*"Behold the hour is at hand, and the Son of man shall
be betrayed into the hands of sinners. Rise, let us go."*

Matthew 26:45–46

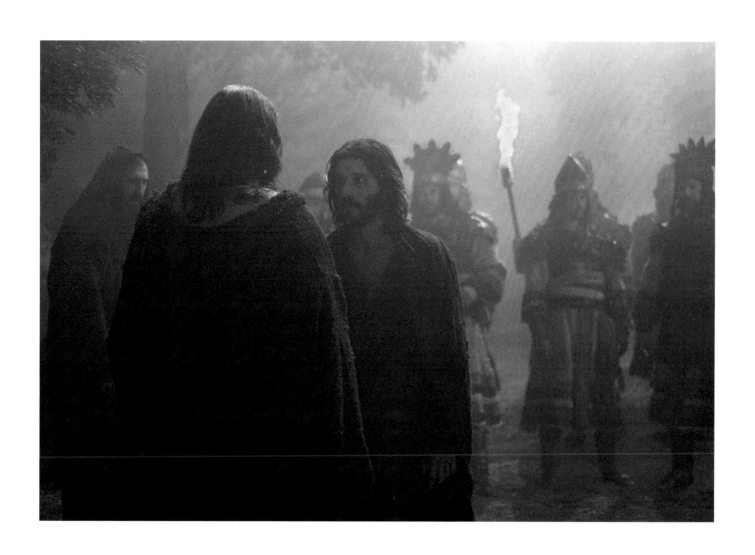

"Behold, he that will betray me is at hand."

Mark 14:42

SHLAM RABBANA

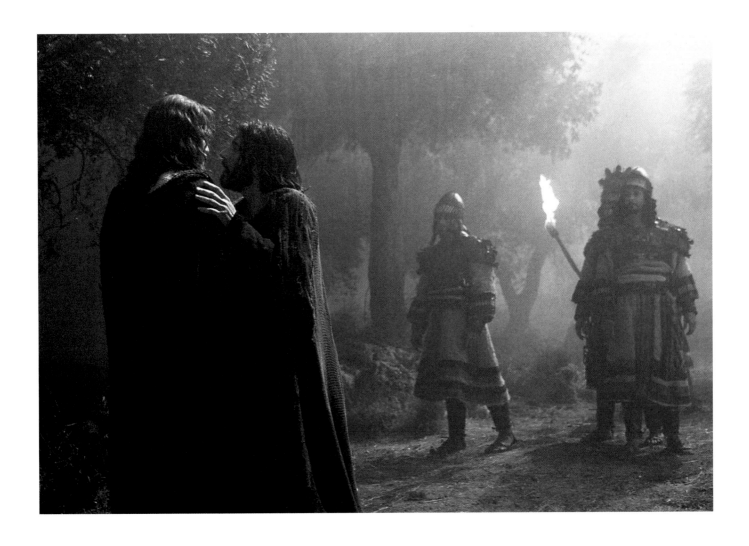

"Hail, Rabbi."

"Friend, whereto art thou come?"

Matt. 26:49-50

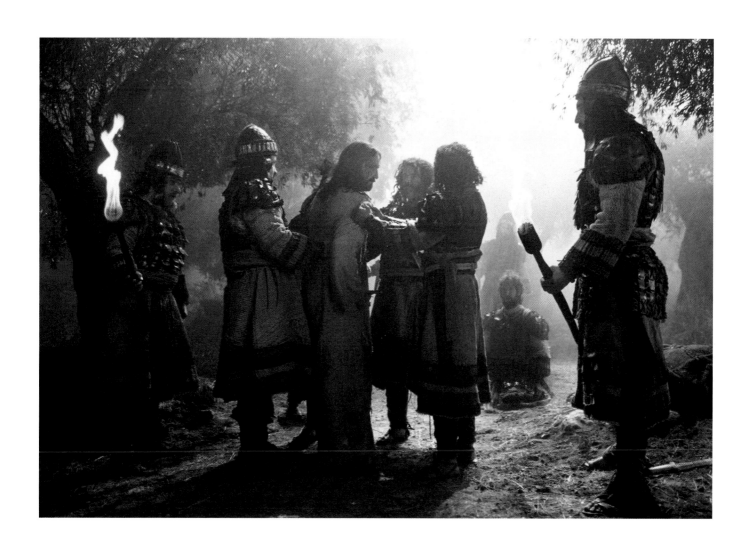

Then they came up and laid hands on Jesus, and held him.

Matthew 26:50

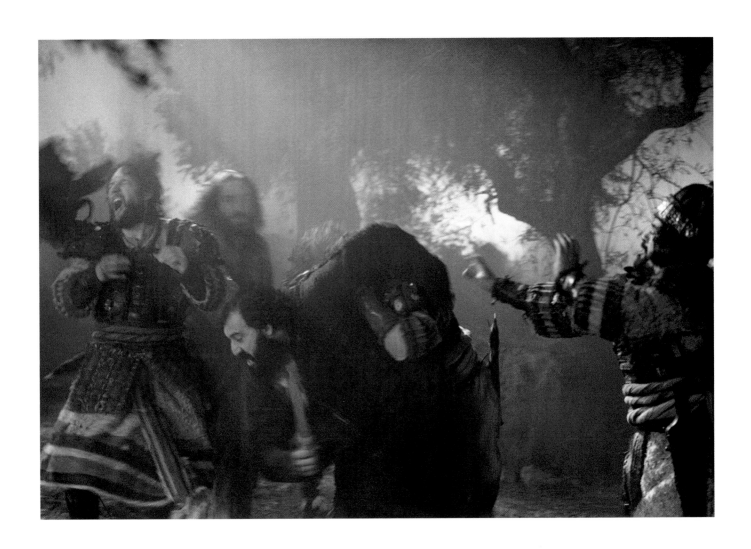

And one of them struck the servant of
the high priest, and cut off his right ear.
Luke 22:50

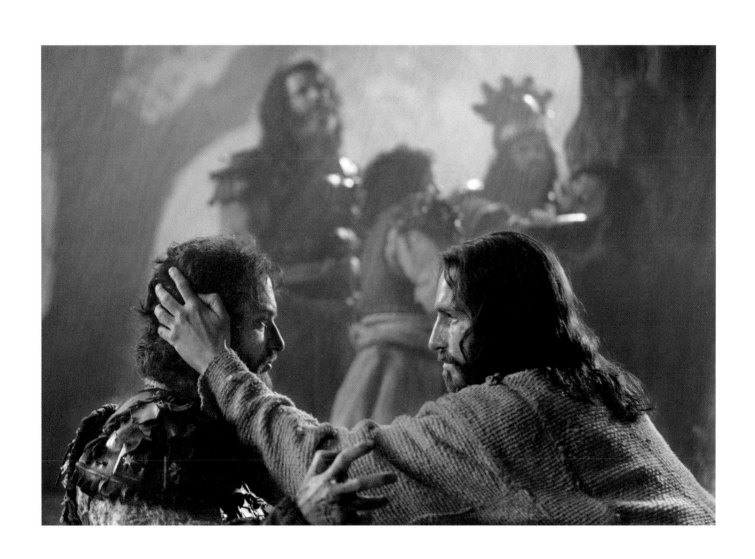

And when he had touched his ear, he healed him.

Luke 22:51

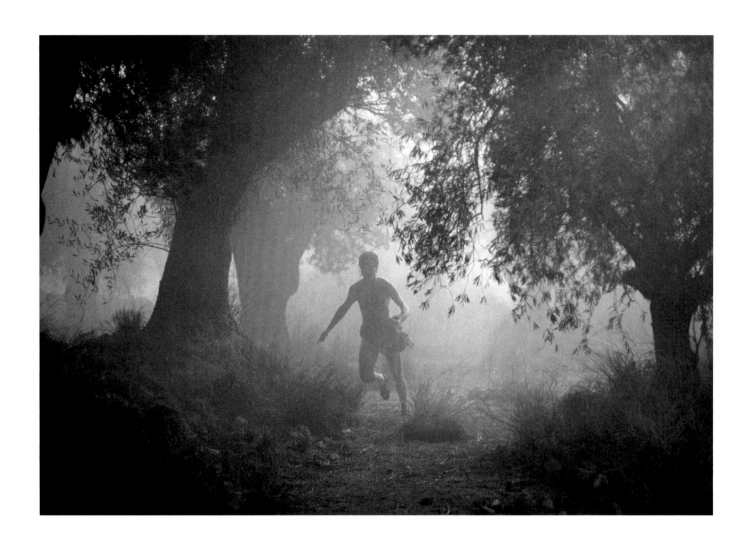

Then his disciples leaving him, all fled away. And a certain young man
followed him, having a linen cloth cast about his naked body; and they
laid hold on him. But he, casting off the linen cloth, fled from them naked.

Mark 14:50–52

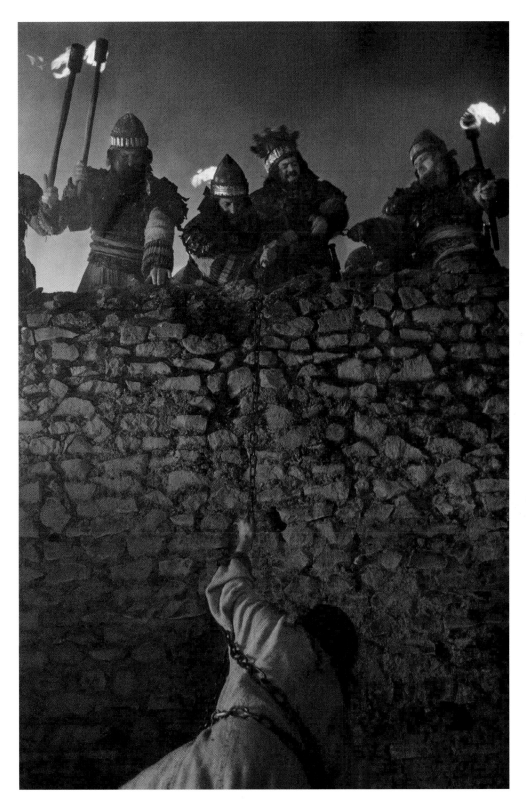

The soldiers maltreat and make sport of Jesus.

NESOLEH!

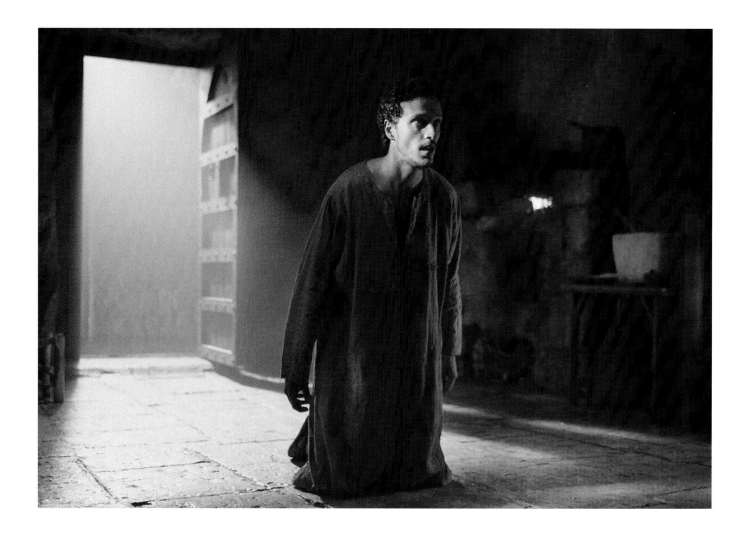

They've seized him!

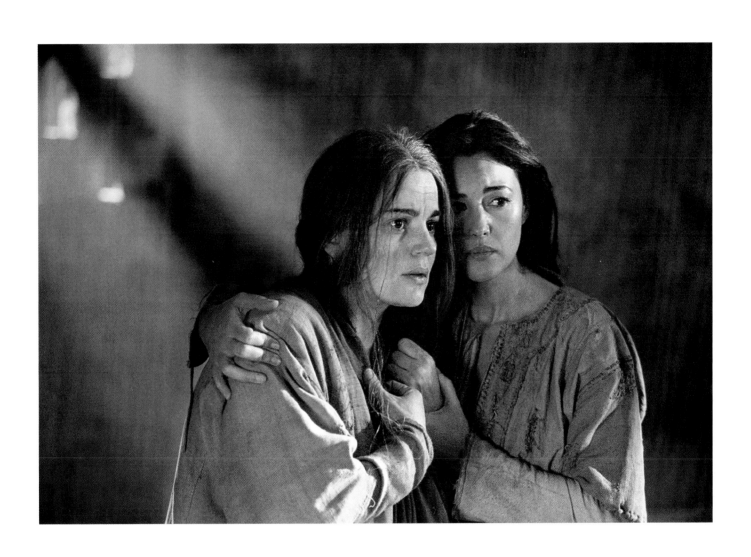

JESUS IS ARRESTED

Then the band and the tribune, and the servants of the Jews, took Jesus, and bound him: And they led him away to Annas first, for he was father-in-law to Caiphas, who was the high priest of that year. Now Caiphas was he who had given the counsel to the Jews: That it was expedient that one man should die for the people.

And Simon Peter followed Jesus, and so did another disciple. And that disciple was known to the high priest, and went in with Jesus into the court of the high priest. But Peter stood at the door without. The other disciple, therefore, who was known to the high priest, went out and spoke to the portress, and brought in Peter.

The high priest therefore asked Jesus of his disciples, and of his doctrine. Jesus answered him: "I have spoken openly to the world: I have always taught in the synagogue, and in the temple, whither all the Jews resort; and in secret I have spoken nothing. Why asketh thou me? Ask them who have heard what I have spoken unto them; behold, they know what things I have said."

And when he had said these things, one of the servants standing by, gave Jesus a blow, saying: "Answerest thou the high priest so?"

Jesus answered him: "If I have spoken evil, give testimony of the evil; but if well, why strikest thou me?"

And Annas sent him bound to Caiphas the high priest.

John 18:12–16, 19–24

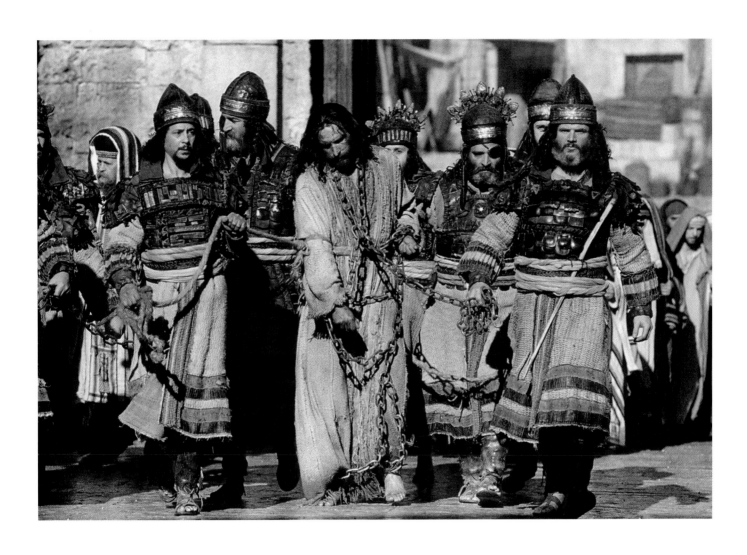

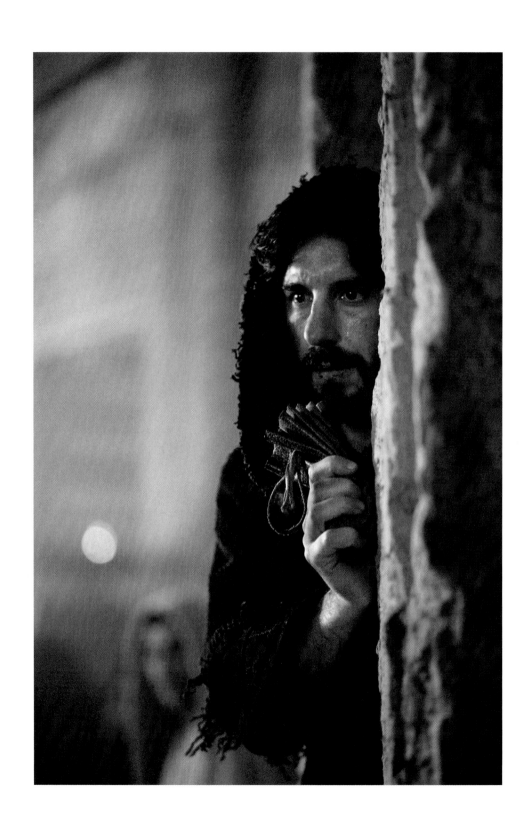

Judas watches from afar.

(Cf. Matthew 27:3)

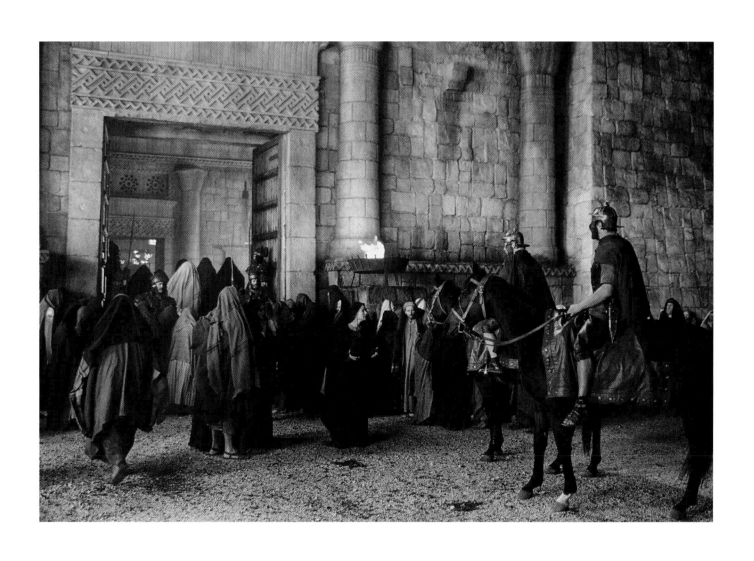

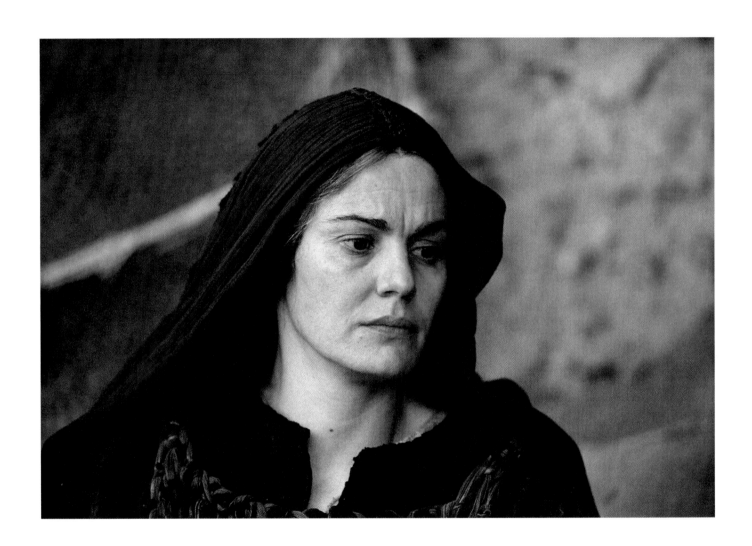

*How came this man by all these things? And what wisdom
is this that is given to him, and such mighty works as are
wrought by his hands? Is not this the carpenter, the son
of Mary?*

Mark 6:2–3

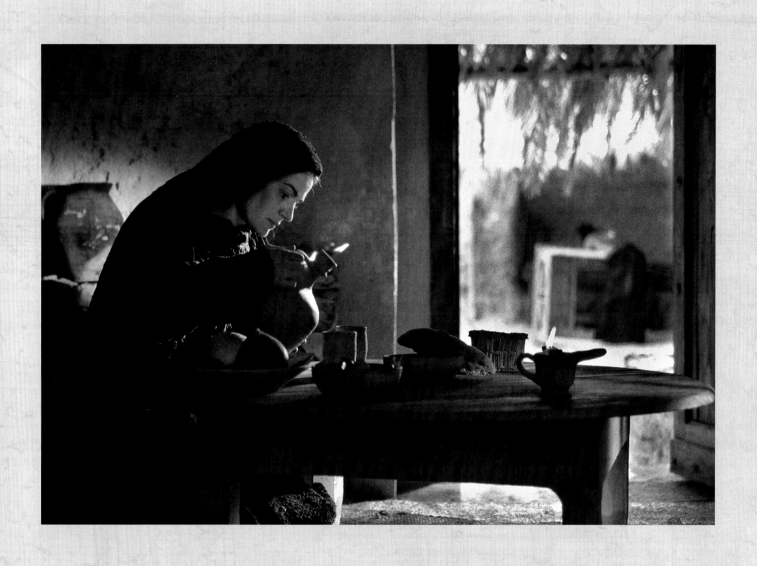

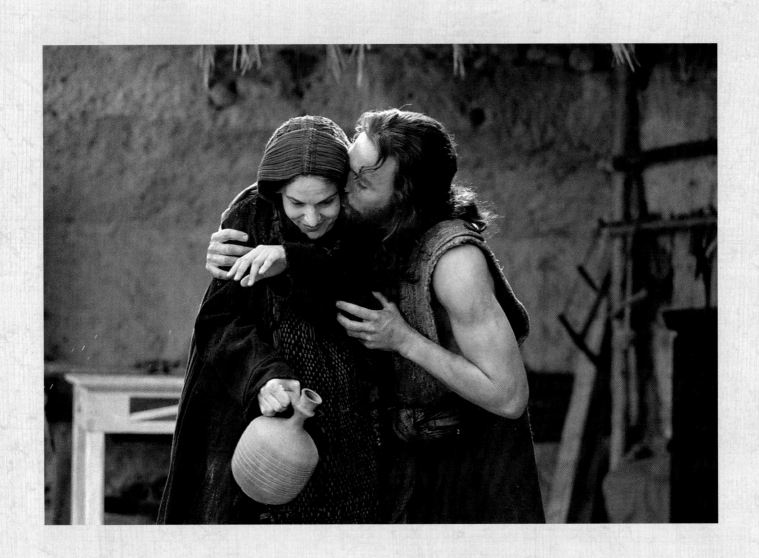

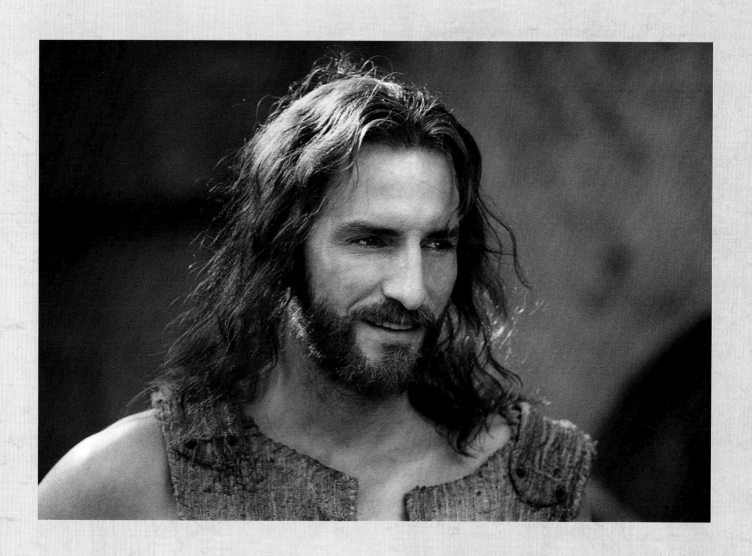

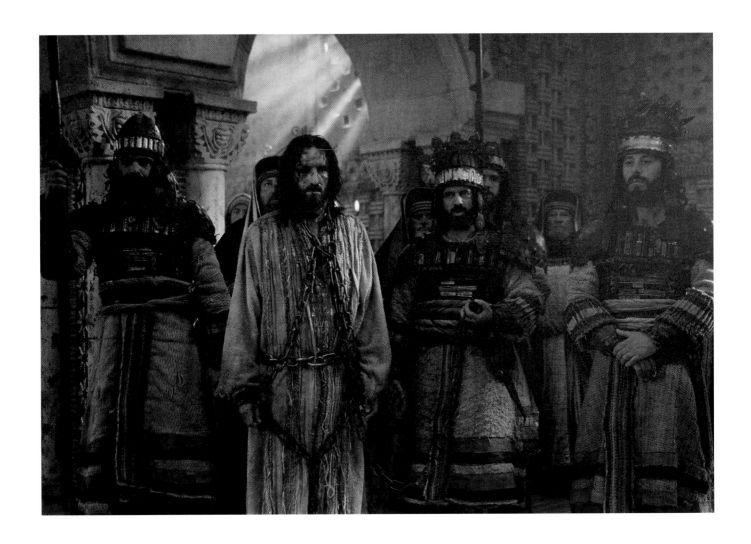

The high priest therefore asked Jesus of his disciples, and of his doctrine.
Jesus answered him: "I have spoken openly to the world: I have always taught
in the synagogue and in the temple, whither all the Jews resort; and in secret
I have spoken nothing. Why askest thou me? Ask them who have heard what
I have spoken unto them; behold, they know what things I have said."

John 18:19–21

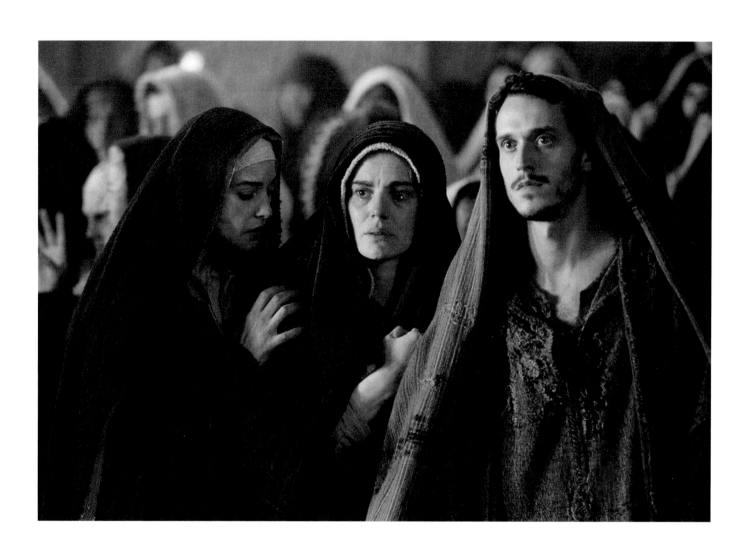

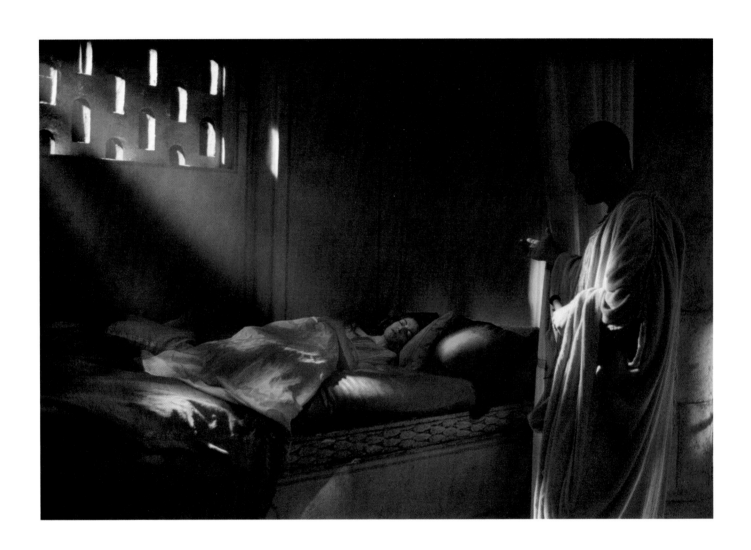

Pilate's wife, Claudia, has a dream.

(Cf. Matthew 27:19)

JESUS BEFORE CAIPHAS

But they, holding Jesus, led him to Caiphas the high priest, where the scribes and the ancients were assembled. And Peter followed him afar off, even to the court of the high priest. And going in, he sat with the servants, that he might see the end.

And the chief priests and the whole council sought false witness against Jesus, that they might put him to death: And they found not, whereas many false witnesses had come in. And last of all there came two false witnesses. And they said: "This man said, 'I am able to destroy the temple of God, and after three days to rebuild it.'"

And the high priest rising up, said to him: "Answerest thou nothing to the things which these witness against thee?" But Jesus held his peace. And the high priest said to him: "I adjure thee by the living God, that thou tell us if thou be the Christ, the Son of God."

Jesus saith to him: "Thou hast said it. Nevertheless, I say to you, hereafter you shall see the Son of man sitting on the right hand of the power of God, and coming in the clouds of heaven."

Then the high priest rent his garments, saying: "He hath blasphemed; what further need have we of witnesses? Behold, now you have heard the blasphemy. What think you?"

But they answering, said: "He is guilty of death."

Then did they spit in his face, and buffeted him; and others struck his face with the palms of their hands, saying: "Prophesy unto us, O Christ, who is he that struck thee?"

PETER DENIES JESUS

But Peter sat without the court, and there came to him a servant maid, saying: "Thou also wast with Jesus the Galilean."

But he denied before them all, saying: "I know not what thou sayest."

And as he went out of the gate, another maid saw him, and she saith to them that were there: "This man also was with Jesus of Nazareth."

And again he denied with an oath, "I know not the man."

And after a little while they came that stood by, and said to Peter: "Surely thou also art one of them, for even thy speech doth discover thee."

Then he began to curse and to swear that he knew not the man. And immediately the cock crowed. And Peter remembered the word of Jesus which he had said: "Before the cock crow, thou wilt deny me thrice." And going forth, he wept bitterly.

JUDAS HANGS HIMSELF

Then Judas, who betrayed him, seeing that he was condemned, repenting himself, brought back the thirty pieces of silver to the chief priests and ancients, saying: "I have sinned in betraying innocent blood."

But they said: "What is that to us? Look thou to it." And casting down the pieces of silver in the temple, he departed, and went and hanged himself with a halter. But the chief priests, having taken the pieces of silver, said: "It is not lawful to put them into the corbona, because it is the price of blood." And after they had consulted together, they bought with them the potter's field, to be a burying place for strangers. For this cause that field was called Haceldama, that is, the field of blood, even to this day. Then was fulfilled that which was spoken by Jeremias the prophet, saying:

And they took the thirty pieces of silver, the price of him that was prized, whom they prized of the children of Israel. And they gave them unto the potter's field, as the Lord appointed to me.

Matthew 26:57–75, 27:3–10

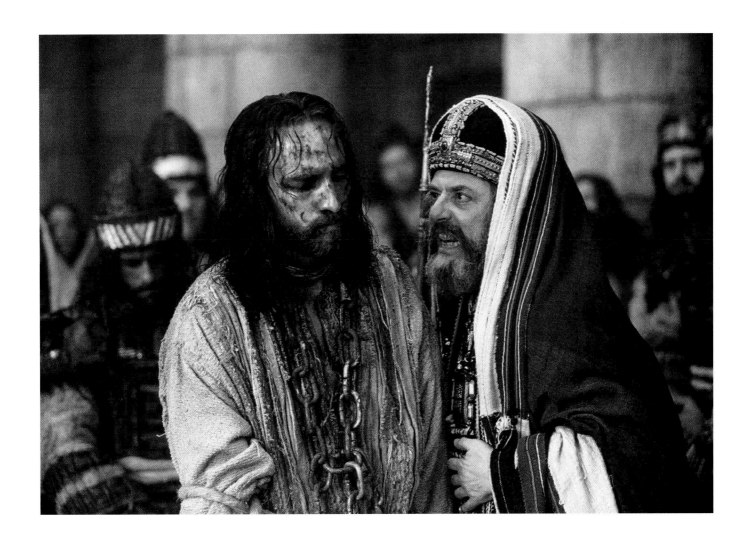

Then the high priest said, "I adjure thee by the living God,
that thou tell us if thou be the Christ, the Son of God."

Matthew 26:63

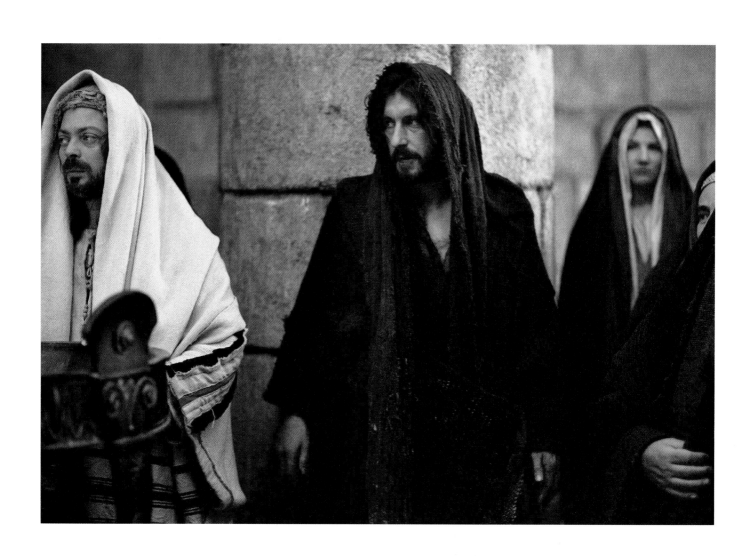

Judas watches.

(Cf. Matthew 27:3)

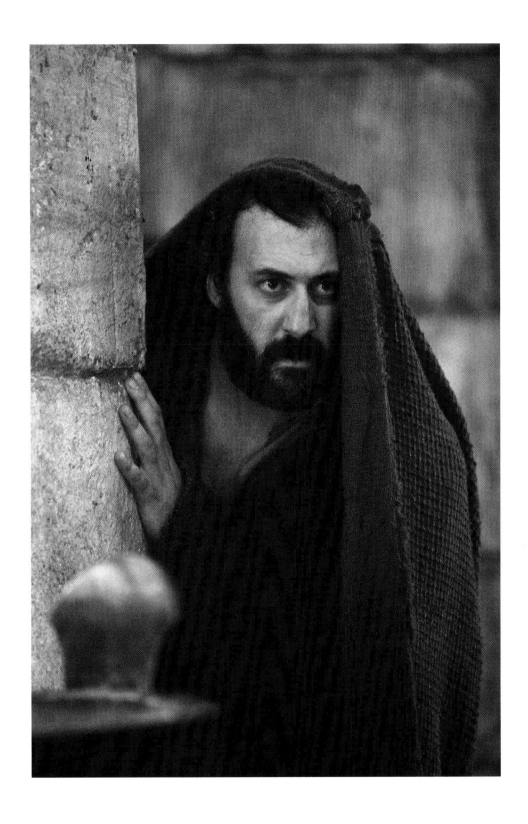

And Peter followed him afar off, even into the court of the high priest.

Mark 14:54

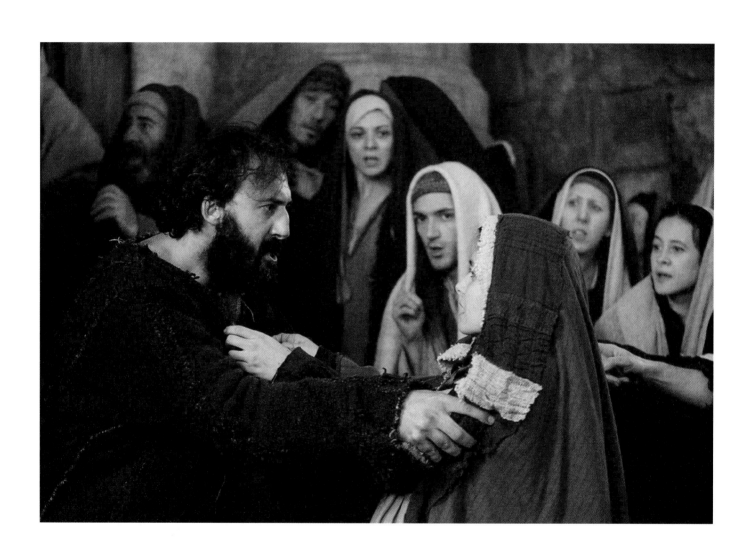

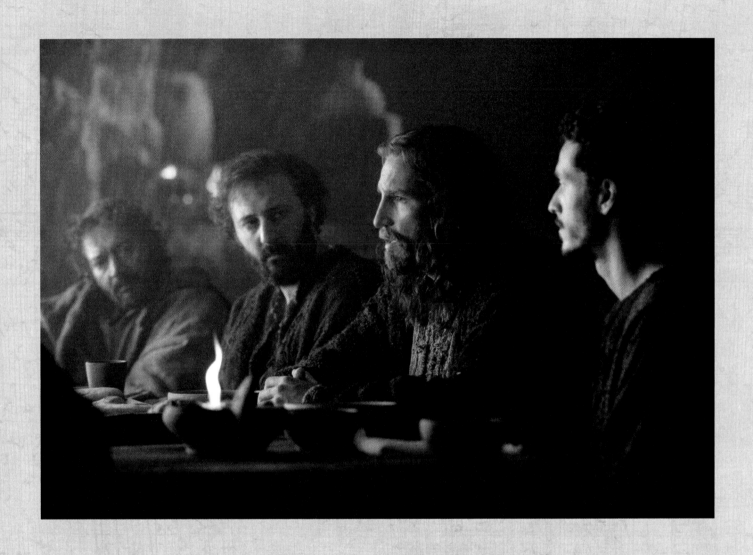

And Peter remembered the word of Jesus which he had said: "Before the cock crow, thou wilt deny me thrice." And going forth, he wept bitterly.

Matthew 26:75

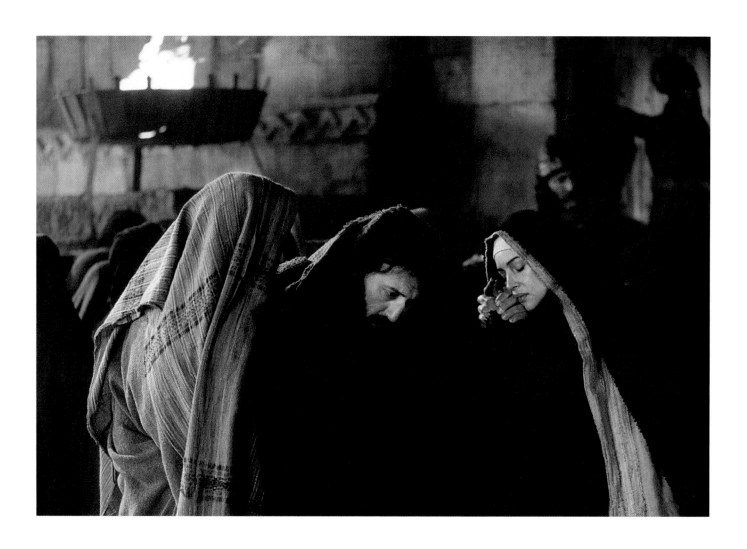

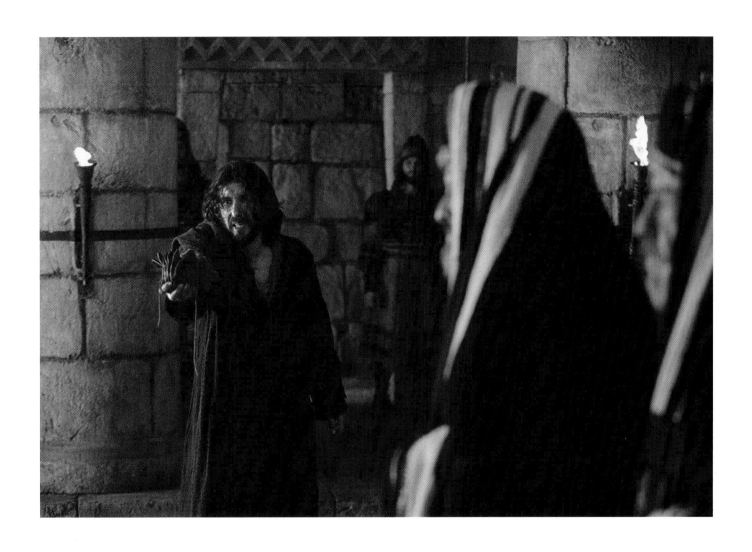

Then Judas, repenting himself, brought back the thirty pieces of silver to the chief priests and ancients, saying: "I have sinned in betraying innocent blood." But they said: "What is that to us? Look thou to it."

Matthew 27:3–4

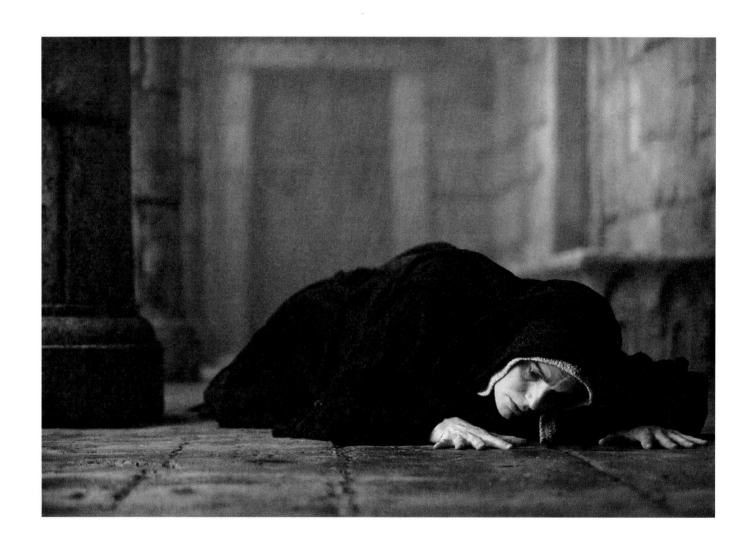

To what shall I compare thee? Or to what shall I liken thee, O daughter of Jerusalem? To what shall
I equal thee, that I may comfort thee, O virgin daughter of Sion? For great as the sea is thy destruction.
O all ye that pass by the way, attend, and see if there be any sorrow like to my sorrow.

Lamentations of Jeremias 2:13, 1:12

Traditional Roman Liturgy, Feast of the Seven Sorrows of Our Lady, September 15

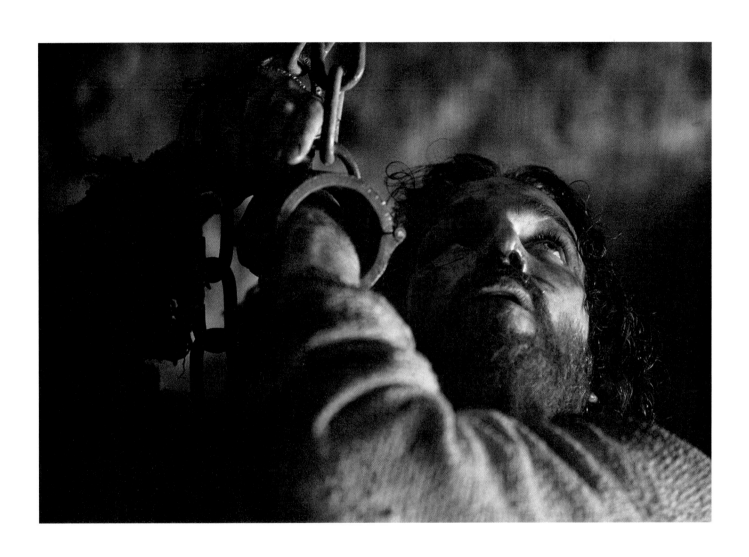

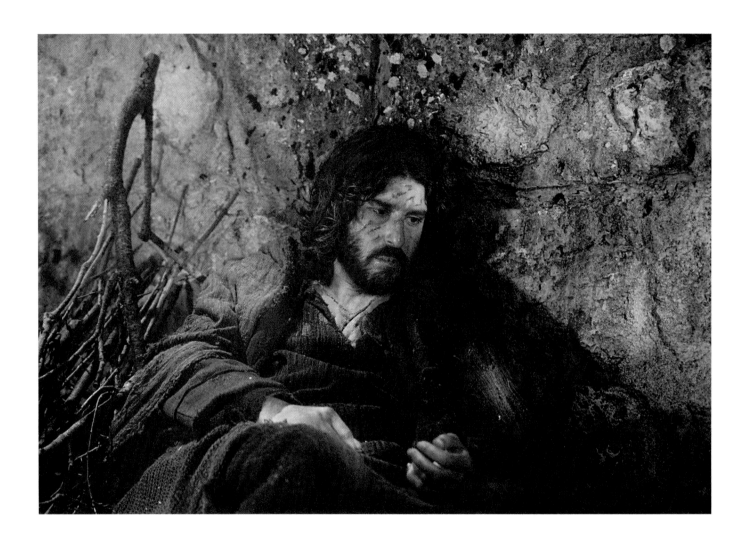

Judas in despair.

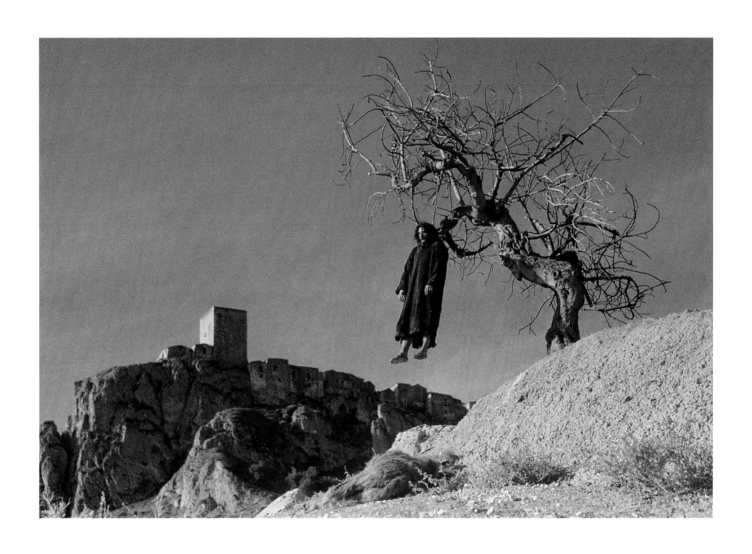

Then Judas went and hanged himself with a halter.

(Cf. Matthew 27:5)

NOLI HUNC HOMINEM GALILAEUM CONDEMNARE. SANCTUS EST.

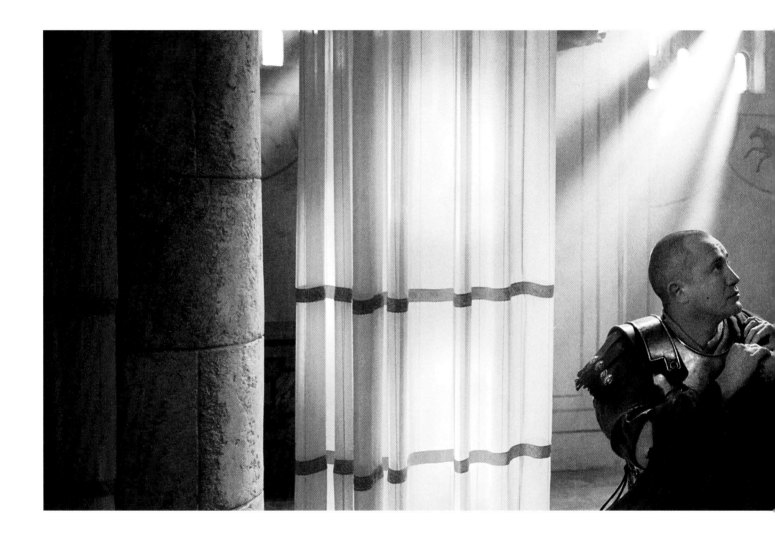

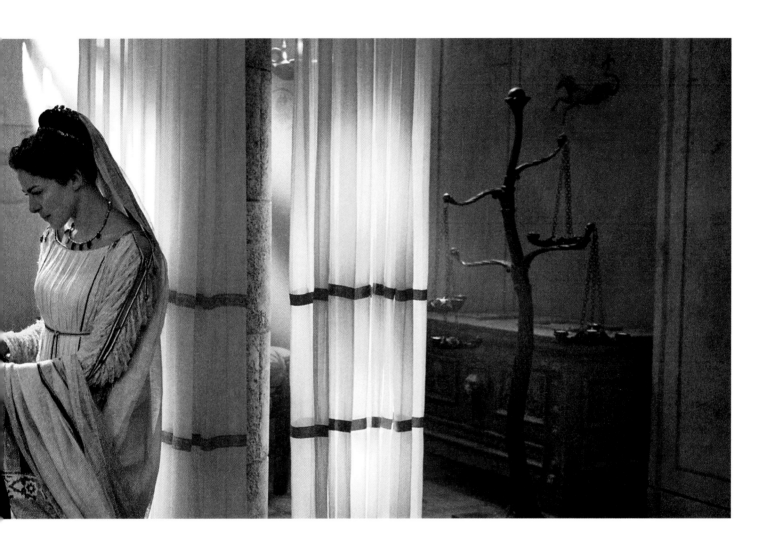

Do not condemn this Galilean. He is holy.

(Cf. Matthew 27:19)

JESUS BEFORE PILATE

Then they led Jesus from Caiphas to the governor's hall. And it was morning; and they went not into the hall, that they might not be defiled, but that they might eat the pasch. Pilate therefore went out to them, and said: "What accusation bring you against this man?"

And they began to accuse him, saying: "We have found this man perverting our nation, and forbidding to give tribute to Caesar, and saying that he is Christ the king. If he were not a malefactor, we would not have delivered him up to thee."

Pilate therefore said to them: "Take him you, and judge him according to your law."

The Jews therefore said to him: "It is not lawful for us to put any man to death."

Pilate therefore went into the hall again, and called Jesus, and said to him: "Art thou the king of the Jews?"

Jesus answered: "Sayest thou this thing of thyself, or have others told it thee of me?"

Pilate answered: "Am I a Jew? Thy own nation, and the chief priests, have delivered thee up to me: what hast thou done?"

Jesus answered: "My kingdom is not of this world. If my kingdom were of this world, my servants would certainly strive that I should not be delivered to the Jews; but now my kingdom is not from hence."

Pilate therefore said to him: "Art thou a king then?"

Jesus answered: "Thou sayest that I am a king. For this was I born, and for this came I into the world, that I should give testimony to the truth. Everyone that is of the truth heareth my voice."

Pilate saith to him: "What is truth?"

And when he said this, he went out again to the Jews, and saith to them: "I find no cause in him."

But they were more earnest, saying: "He stirreth up the people, teaching throughout all Judea, beginning from Galilee to this place."

But Pilate hearing Galilee, asked if the man were of Galilee. And when he understood that he was of Herod's jurisdiction, he sent him away to Herod, who was also himself at Jerusalem in those days.

JESUS BEFORE HEROD

And Herod, seeing Jesus, was very glad; for he was desirous of a long time to see him, because he had heard many things of him; and he hoped to see some sign wrought by him. And he questioned him in many words. But he answered him nothing.

And the chief priests and the scribes stood by, earnestly accusing him. And Herod with his army set him at nought, and mocked him, putting on him a white garment, and sent him back to Pilate. And Herod and Pilate were made friends that same day, for before they were enemies one to another.

JESUS RETURNED TO PILATE

Now on the festival day, he [Pilate] was wont to release unto them one of the prisoners, whomsoever they demanded. And there was one called Barabbas, who was put in prison with some seditious men, who in the sedition had committed murder. And when the multitude was come up, they began to desire that he would do as he had ever done unto them.

And Pilate, calling together the chief priests and the magistrates, and the people, said to them: "You have presented unto me this man, as one that perverteth the people; and behold I, having examined him before you, find no cause in this man, in those things wherein you accuse him. No, nor Herod neither. For I sent you to him, and behold, nothing worthy of death is done to him. I will chastise him, therefore, and release him."

John 18:28–31, 33–38; Luke 23:2, 4–16; Mark 15:6–8

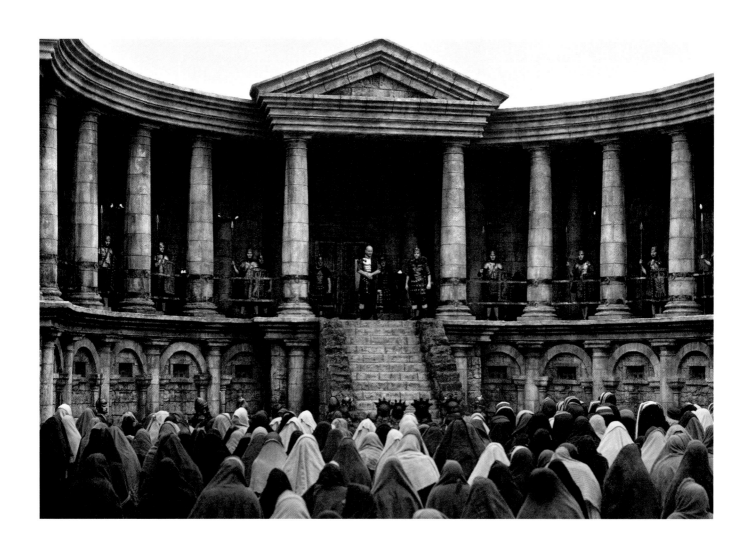

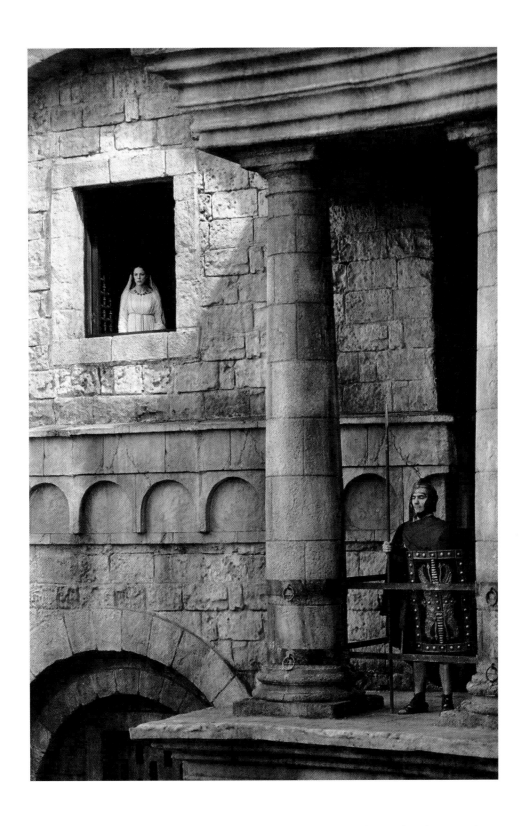

Claudia watches the proceedings.

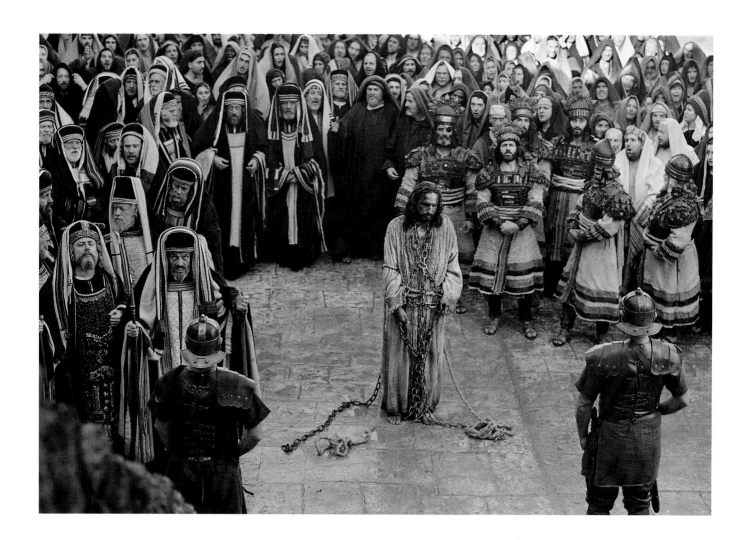

Pilate therefore went out to them, and said:

"What accusation bring you against this man?"

John 18:29

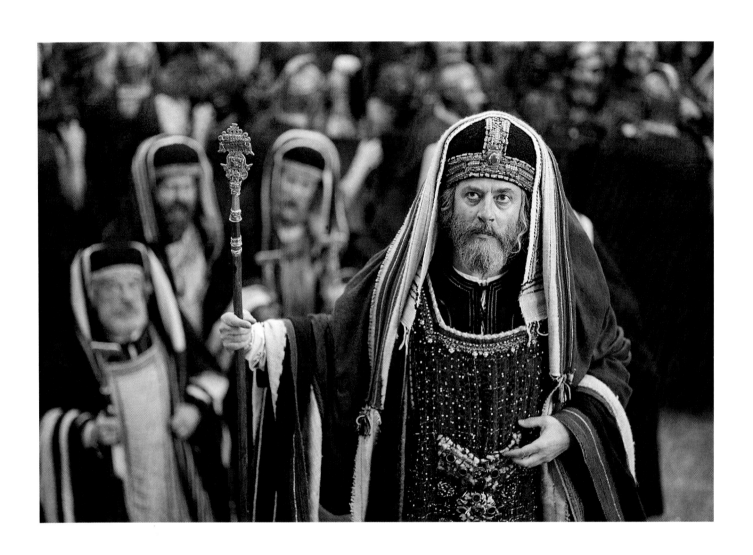

They answered, and said to him: "If he were not a
malefactor, we would not have delivered him up to thee."

John 18:30

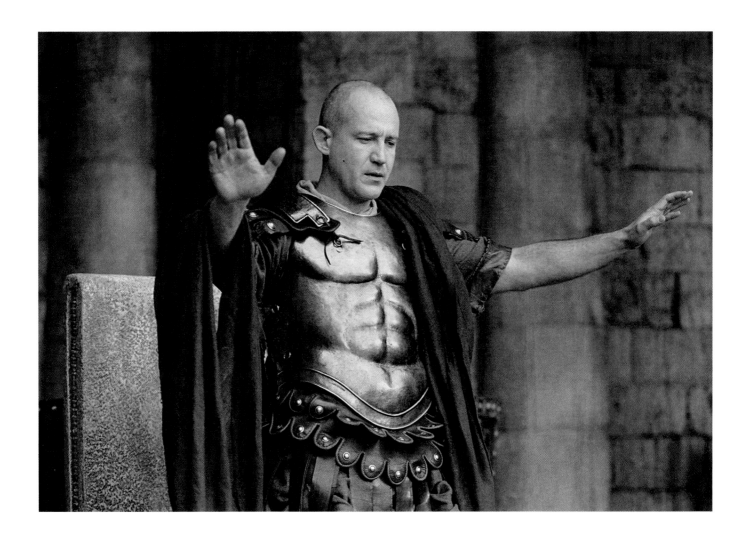

Can any of you explain this madness to me?

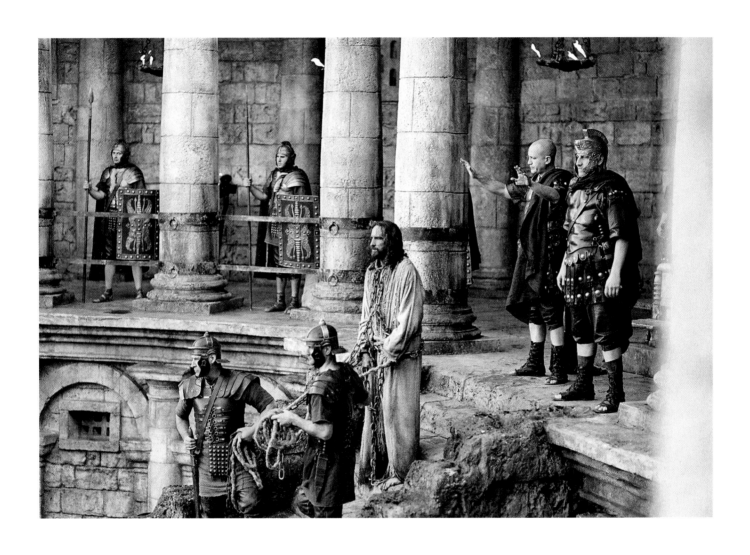

Pilate therefore said to them: "Take him you,
and judge him according to your law."

John 18:31

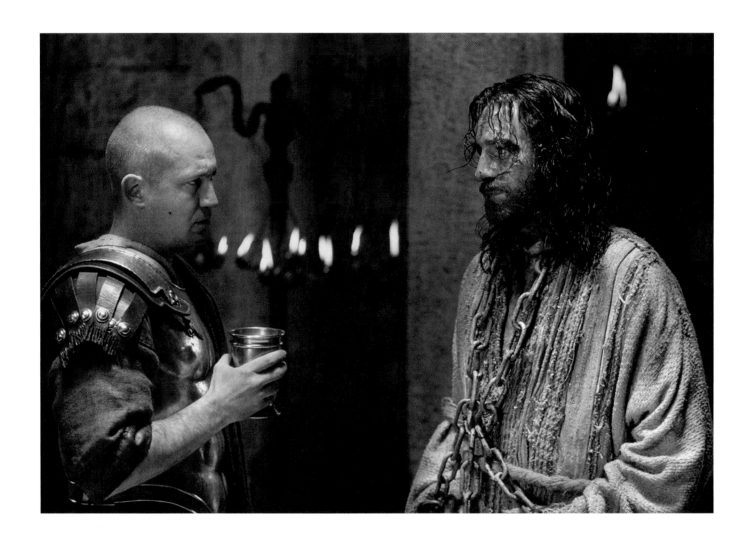

"Art thou a king then?"

John 18:37

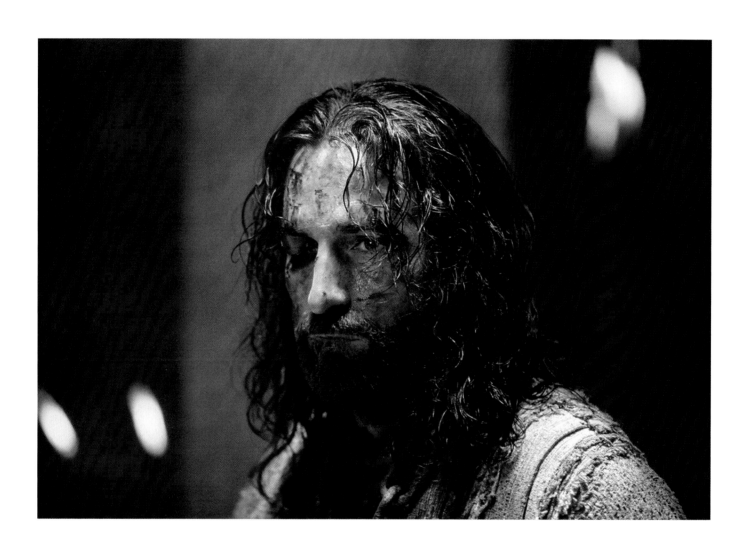

"*Thou sayest that I am a king. For this was I born, and for this came I into the world, that I should give testimony to the truth. Everyone that is of the truth heareth my voice.*"

John 18:37

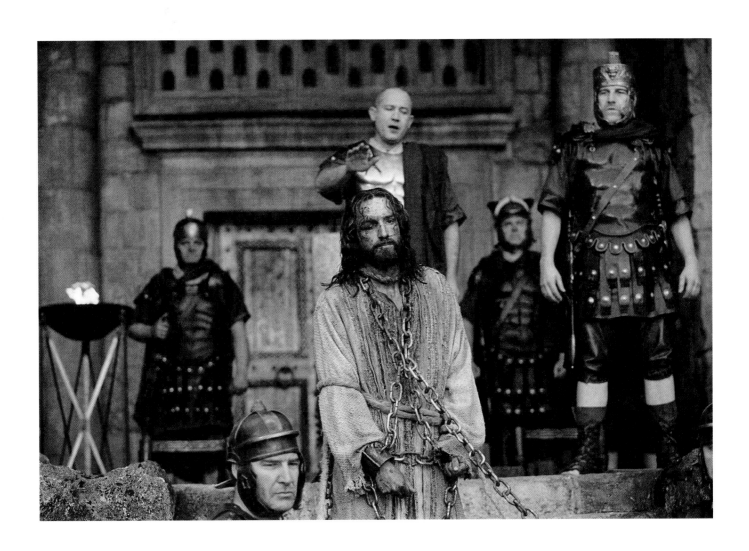

And Pilate said to the chief priests and to
the multitudes: "I find no cause in this man."

Luke 23:4

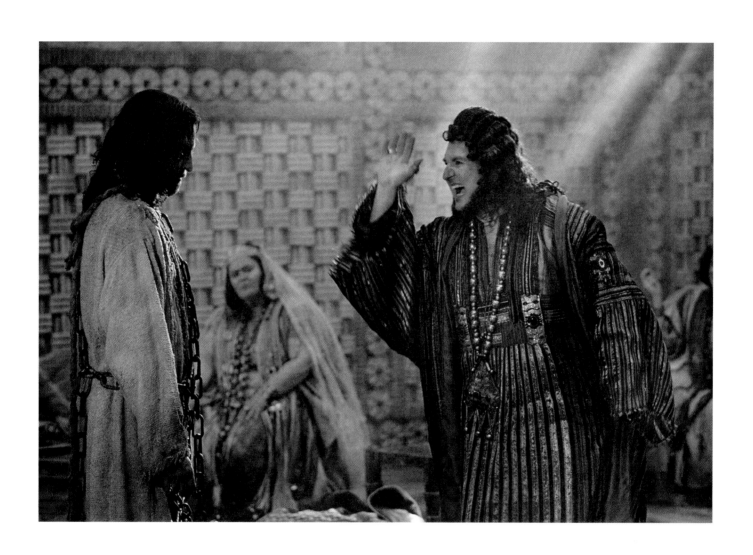

When he understood that he was of Herod's jurisdiction, he sent him away to Herod. And he questioned him in many words. But he answered him nothing. And Herod with his army set him at nought, and mocked him, putting on him a white garment, and sent him back to Pilate.

Luke 23:7, 9, 11

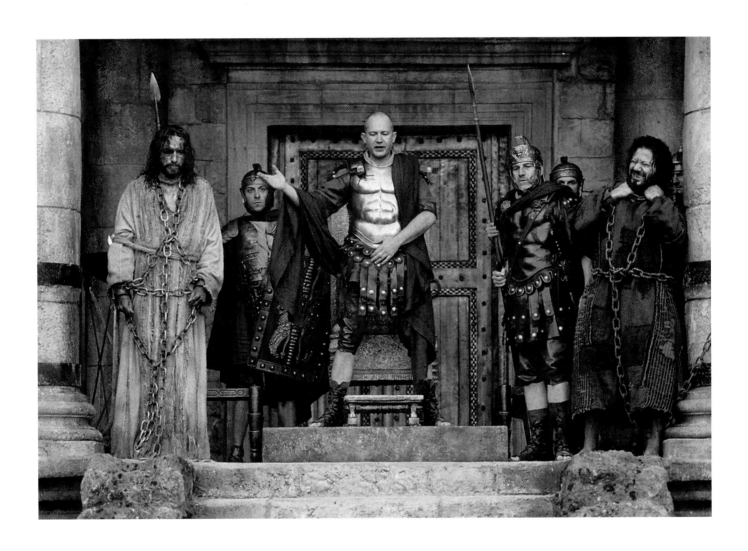

"What shall I do then with Jesus, that is called Christ?"

Matthew 27:22

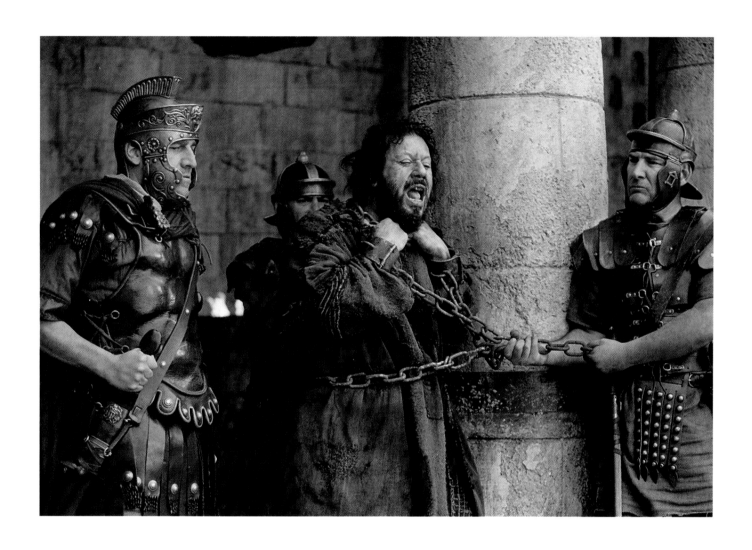

"But you have a custom that I should release one unto you at the pasch: Will you, therefore, that I release unto you the king of the Jews?" Then cried they all again, saying: "Not this man, but Barabbas." Now Barabbas was a robber.

John 18:39-40

JESUS IS SCOURGED; BARABBAS IS RELEASED

Then, therefore, Pilate took Jesus and scourged him.

Pilate therefore went forth again and saith to them: "Behold, I bring him forth unto you, that you may know that I find no cause in him." And he saith to them: "Behold the Man."

But the chief priests and ancients persuaded the people that they should ask [for] Barabbas, and make Jesus away. And the governor answering, said to them: "Whether will you of the two to be released unto you?" But they said, "Barabbas."

Pilate saith to them: "What shall I do then with Jesus, that is called Christ?"

They say all: "Let him be crucified."

The governor said to them: "Why, what evil hath he done?"

But they cried out the more, saying: "Let him be crucified."

Pilate saith to them: "Take him you, and crucify him: for I find no cause in him."

The Jews answered him: "We have a law; and according to the law he ought to die, because he made himself the Son of God."

When Pilate therefore had heard this saying, he feared the more. And he entered into the hall again, and he said to Jesus: "Whence art thou?" But Jesus gave him no answer. Pilate therefore saith to him: "Speakest thou not to me? Knowest thou not that I have power to crucify thee, and I have power to release thee?"

Jesus answered: "Thou shouldst not have any power against me, unless it were given thee from above. Therefore, he that hath delivered me to thee hath the greater sin."

And from henceforth Pilate sought to release him. But the Jews cried out, saying: "If thou release this man, thou art not Caesar's friend. For whosoever maketh himself a king, speaketh against Caesar."

JESUS SENTENCED TO DEATH

Now when Pilate had heard these words, he brought Jesus forth, and sat down in the judgment seat, in the place that is called Lithostrotos, and in Hebrew Gabbatha. And it was the parasceve of the pasch, about the sixth hour, and he saith to the Jews: "Behold your king."

But they cried out: "Away with him; away with him; crucify him."

Pilate saith to them: "Shall I crucify your king?"

The chief priests answered: "We have no king but Caesar."

And Pilate, seeing that he prevailed nothing, but that rather a tumult was made, taking water, washed his hands before the people, saying: "I am innocent of the blood of this just man; look you to it."

But they were insistent with loud voices, requiring that he might be crucified; and their voices prevailed. And Pilate gave sentence that it should be as they required. And he released unto them him who for murder and sedition had been cast into prison, whom they had desired.

Then the soldiers of the governor taking Jesus into the hall, gathered together unto him the whole band; and stripping him, they put a scarlet cloak about him. And platting a crown of thorns, they put it upon his head, and a reed in his right hand. And bowing the knee before him, they mocked him, saying: "Hail, king of the Jews." And spitting upon him, they took the reed and struck his head. And after they had mocked him, they took off the cloak from him and put on him his own garments, and led him away to crucify him.

John 19:1, 4–5; 6–15; Matthew 27:20–24, 27–31; Luke 23:23–25

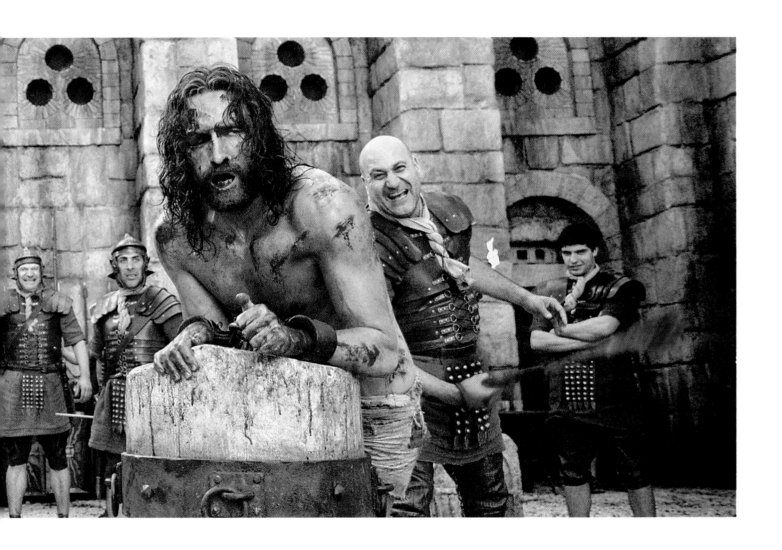

Then, therefore, Pilate took Jesus and scourged him.

John 19:1

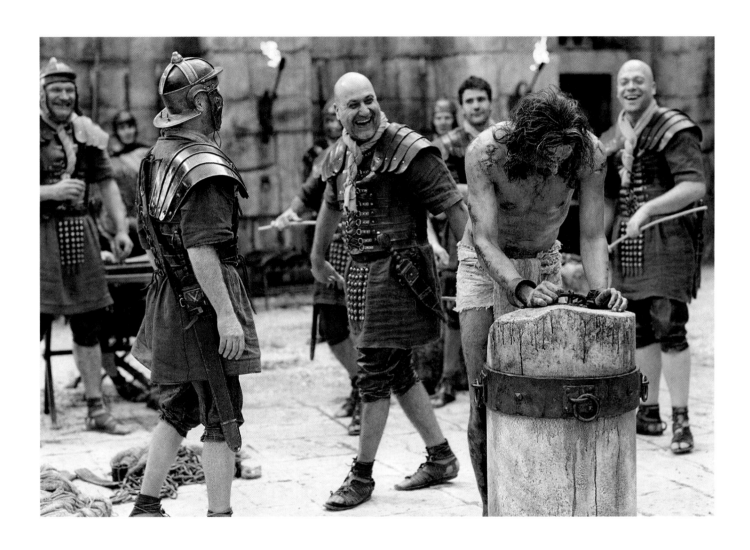

62 | THE PASSION

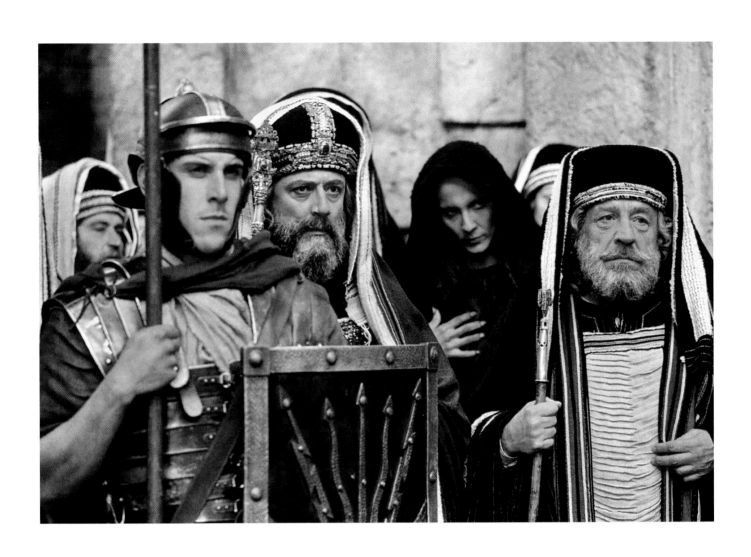

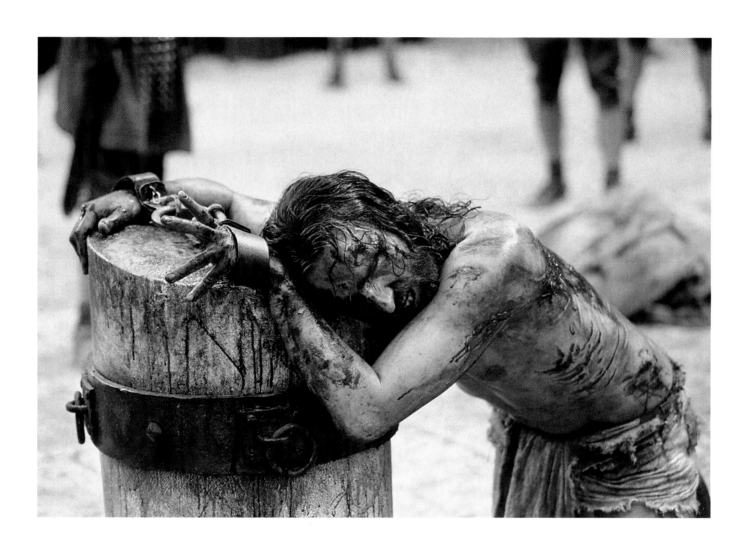

He shall be led as a sheep to the slaughter, and shall be dumb
as a lamb before his shearer, and he shall not open his mouth.

Isaias 53:7

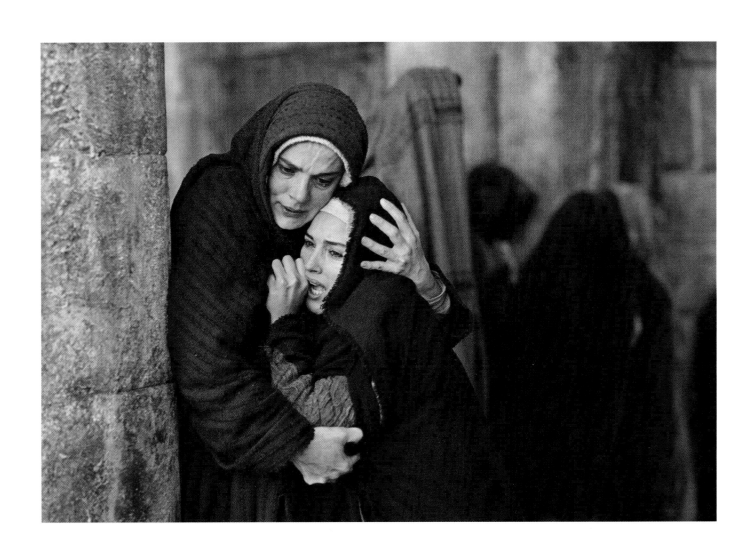

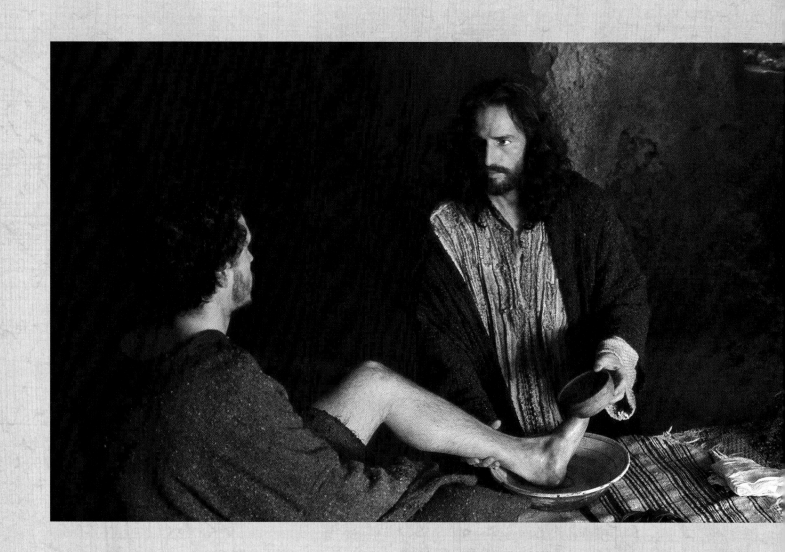

Before the festival day of the Pasch, he riseth from supper and began to wash
the feet of the disciples. Then after he had washed their feet, he said to them:
"For I have given you an example, that as I have done to you, so you do also."

John 13:1, 4–5, 12, 15

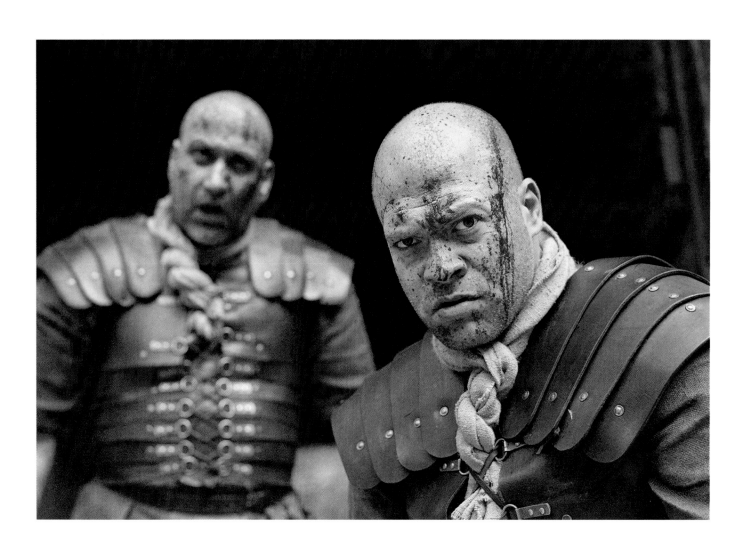

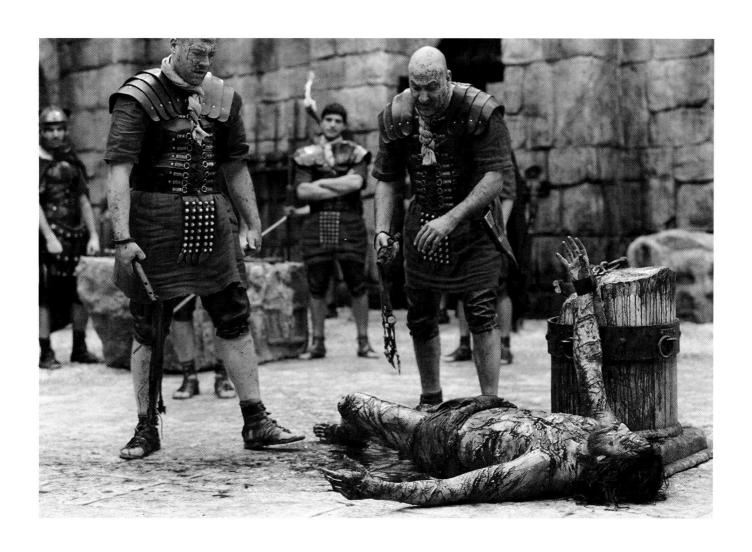

As many have been astonished at thee, so shall his visage be inglorious among men, and his form among the sons of men.

Isaias 52:14

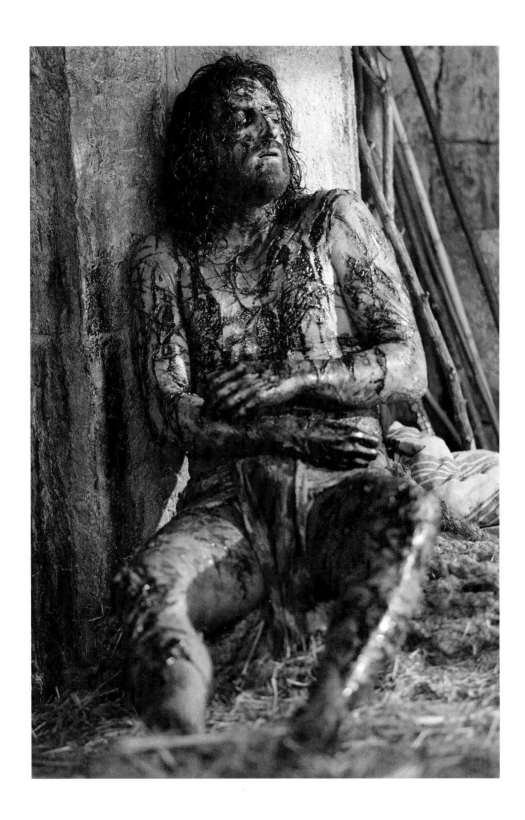

There is no beauty in him, nor comeliness.

Isaias 53:2

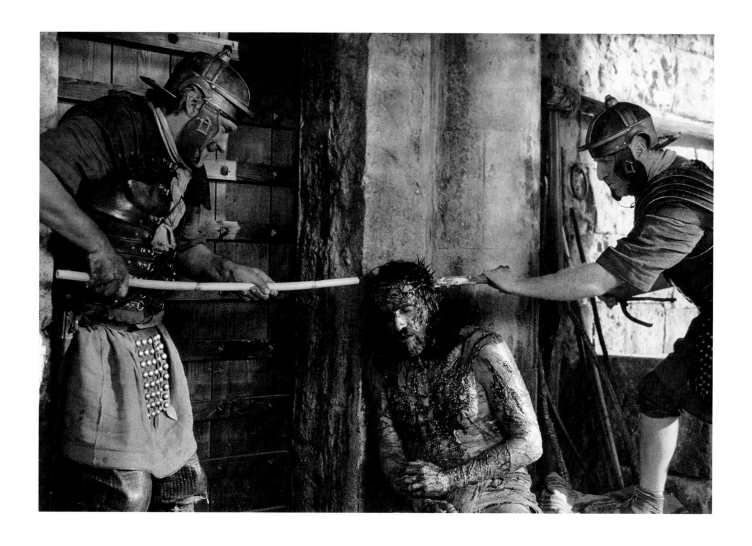

"Hail, king of the Jews."

Matthew 27:29

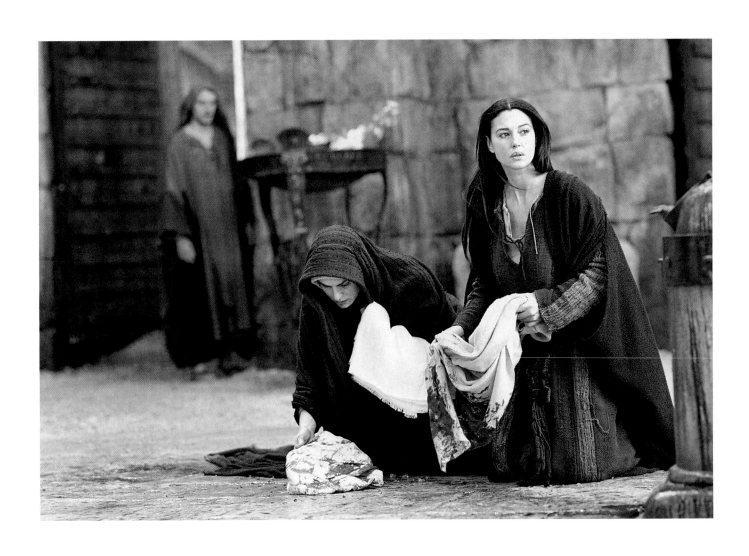

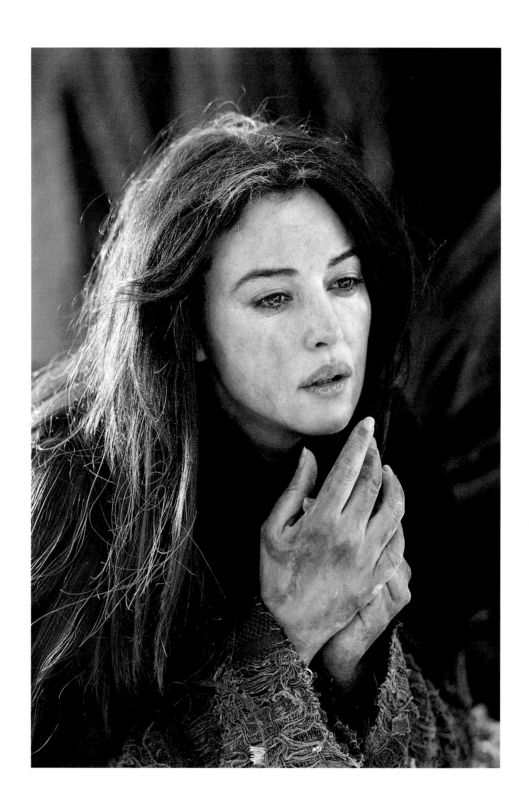

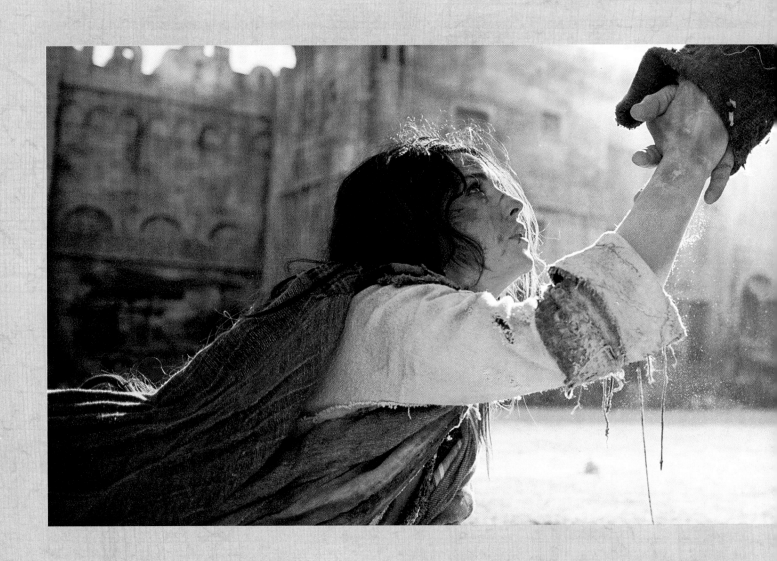

And the scribes and Pharisees bring unto him a woman taken in adultery. But Jesus
said to them: "He that is without sin among you, let him first cast a stone at her."
But they, hearing this, went out one by one, beginning at the eldest. Then Jesus
said to her: "Woman, where are they that accused thee? Go, and now sin no more."

John 8:3, 6–7, 10–11

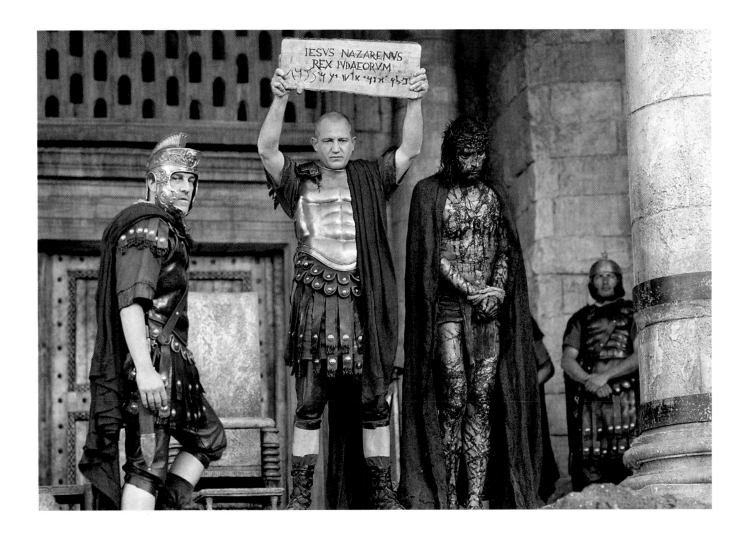

"Behold the Man."

"Behold your king."

John 19:5, 14

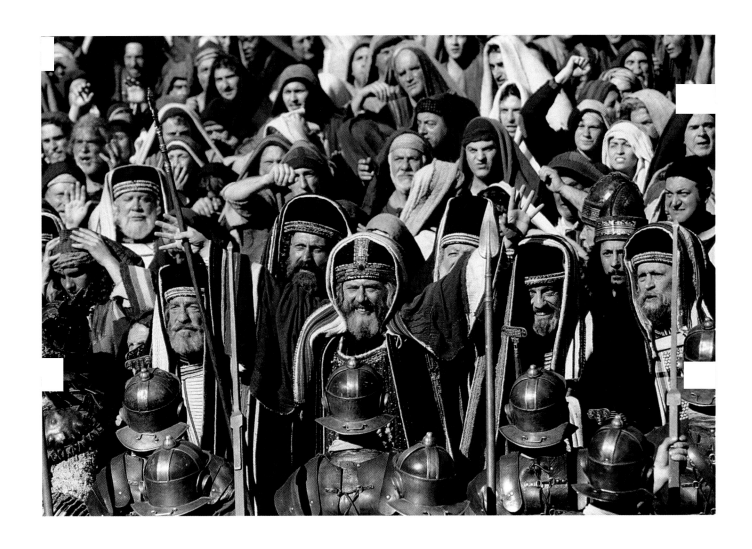

Pilate therefore went forth again, and saith to them: "Behold, I bring him forth unto you, that you may know that I find no cause in him." (Jesus therefore came forth, bearing the crown of thorns and the purple garment.) . . . and he [Pilate] saith to the Jews: "Behold your king." But they cried out: "Away with him; away with him; crucify him." Pilate saith to them: "Shall I crucify your king?" The chief priests answered: "We have no king but Caesar." Then therefore he delivered him to them to be crucified.

John 19:4–5, 14–16

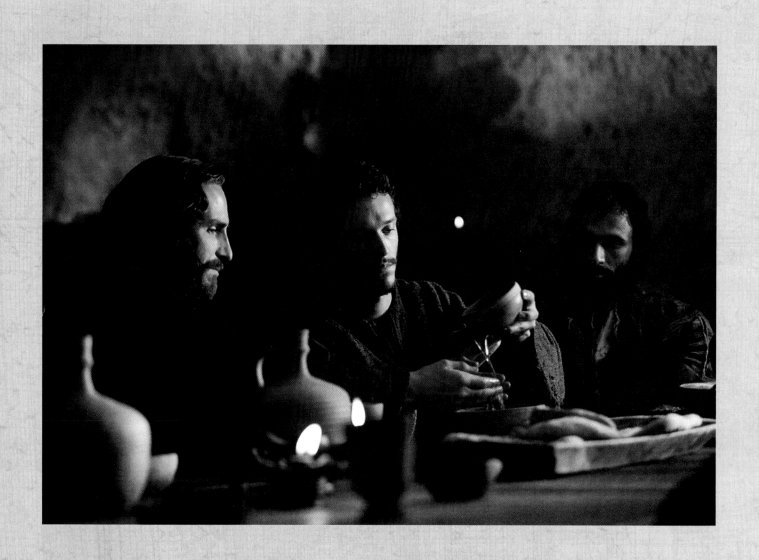

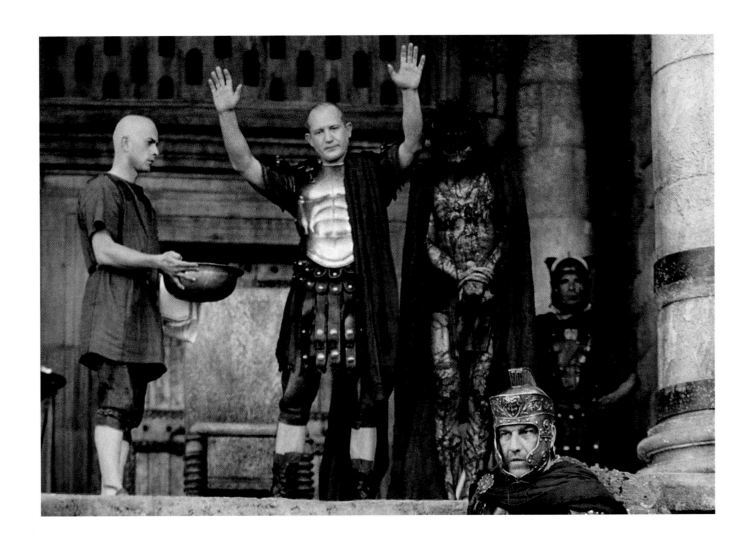

"I am innocent of the blood of this just man."

Matthew 27:24

THE CRUCIFIXION

And as they led him away, they laid hold of one Simon of Cyrene, coming from the country; and they laid the cross on him to carry after Jesus. And there followed him a great multitude of people, and of women, who bewailed and lamented him. But Jesus turning to them, said: "Daughters of Jerusalem, weep not over me, but weep for yourselves, and for your children. For behold, the days shall come wherein they will say: 'Blessed are the barren and the wombs that have not borne, and the paps that have not given suck.' Then shall they begin to say to the mountains: 'Fall upon us,' and to the hills: 'Cover us.' "

And they bring him into the place called Golgotha, which being interpreted is, The place of Calvary. And there were also two other malefactors led with him to be put to death. And when they were come to the place which is called Calvary, they crucified him there; and the robbers, one on the right hand, and the other on the left.

And Jesus said: "Father, forgive them, for they know not what they do."

And the people stood beholding, and the rulers with them derided him, saying: "He saved others; let him save himself, if he be Christ, the elect of God." And the soldiers also mocked him, coming to him, and offering him vinegar, and saying: "If thou be the king of the Jews, save thyself." And there was also a superscription written over him in letters of Greek and Latin and Hebrew: "THIS IS THE KING OF THE JEWS."

This title, therefore, many of the Jews did read, because the place where Jesus was crucified was nigh to the city; and it was written in Hebrew, in Greek and in Latin. Then the chief priests of the Jews said to Pilate: "Write not, The King of the Jews, but that he said, 'I am the King of the Jews.' "

Pilate answered: "What I have written, I have written."

The soldiers therefore, when they had crucified him, took his garments (and they made four parts, to every soldier a part), and also his coat. Now the coat was without seam, woven from the top throughout. They said then one to another: "Let us not cut it, but let us cast lots for it, whose it shall be"; that the scripture might be fulfilled, saying: *They have parted my garments among them, and upon my vesture they have cast lots.* And the soldiers indeed did these things.

And one of those robbers who were hanged, blasphemed him, saying: "If thou be Christ, save thyself and us."

But the other answering, rebuked him, saying: "Neither dost thou fear God, seeing thou art under the same condemnation? And we indeed justly, for we receive the due reward of our deeds; but this man hath done no evil." And he said to Jesus: "Lord, remember me when thou shalt come into thy kingdom." And Jesus said to him: "Amen I say to thee, this day thou shalt be with me in paradise."

Now there stood by the cross of Jesus, his mother and his mother's sister, Mary of Cleophas, and Mary Magdalen. When Jesus therefore had seen his mother and the disciple standing whom he loved, he saith to his mother: "Woman, behold thy son." After that, he saith to the disciple: "Behold thy mother." And from that hour, the disciple took her to his own.

Luke 23:26–30, 32–43; Mark 15:22; John 19:20–27

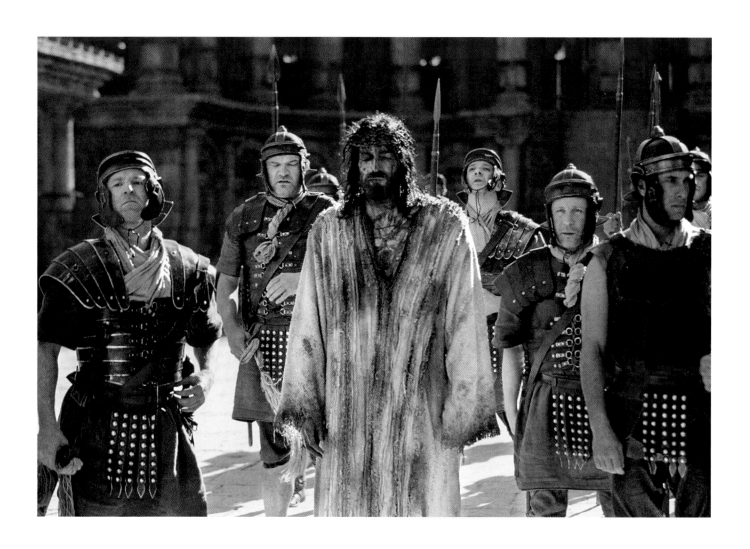

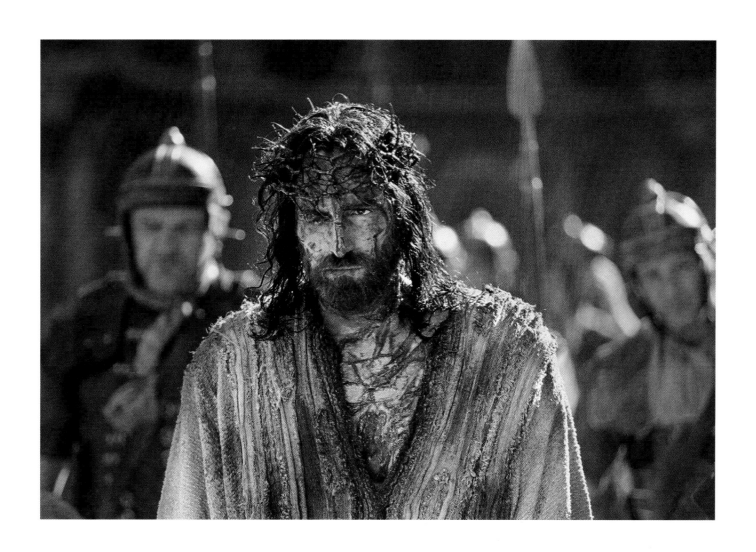

And after they had mocked him, they took off the purple from him, and
put his own garments on him, and they led him out to crucify him.

Mark 15:20

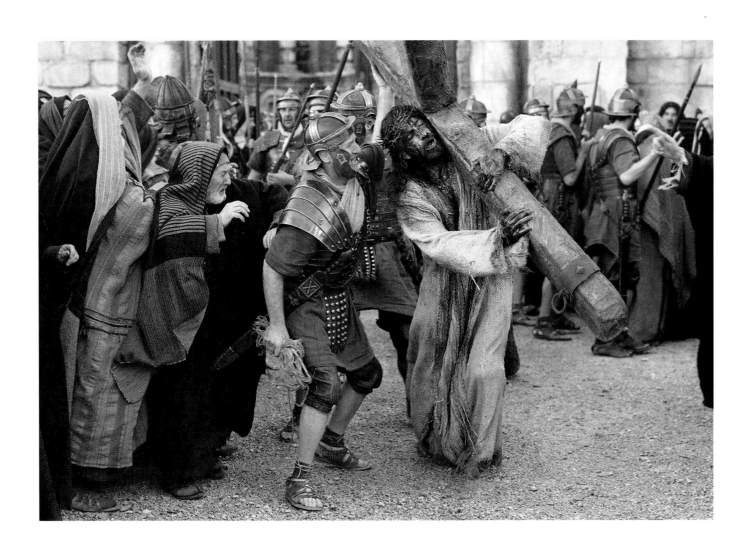

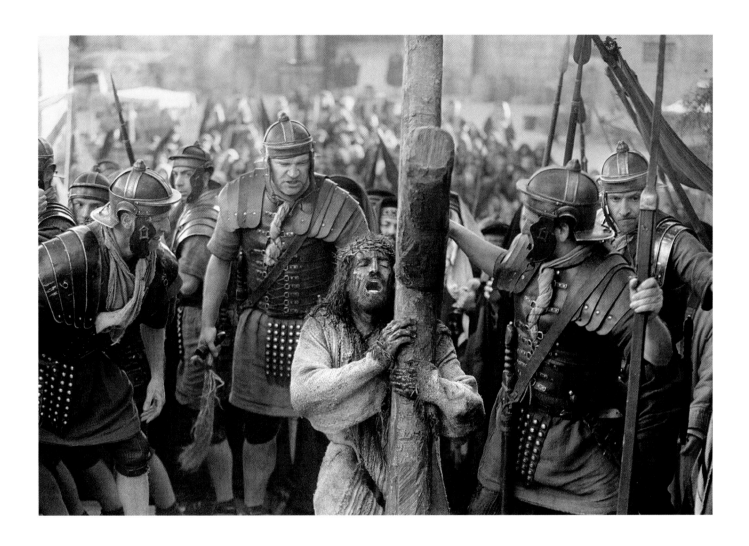

Surely he hath borne our infirmities and carried our sorrows: and we have thought him as it were a leper, and as one struck by God and afflicted. But he was wounded for our iniquities, he was bruised for our sins: the chastisement of our peace was upon him, and by his bruises we are healed.

Isaias 53:4–5

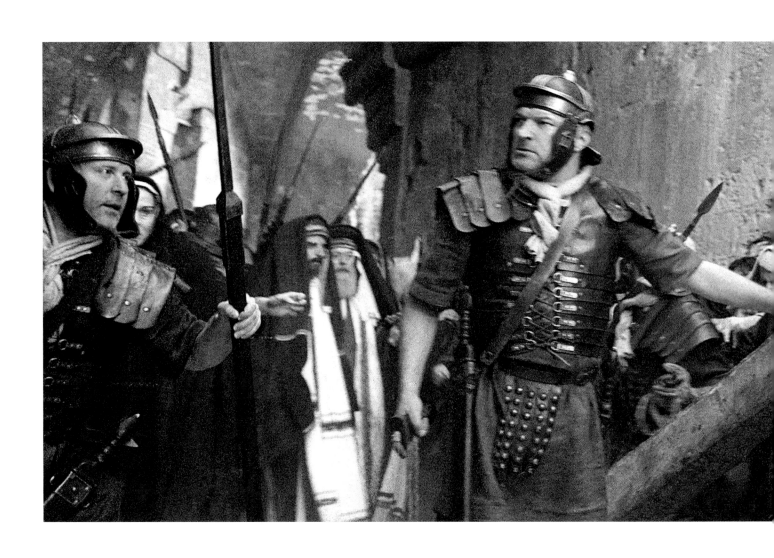

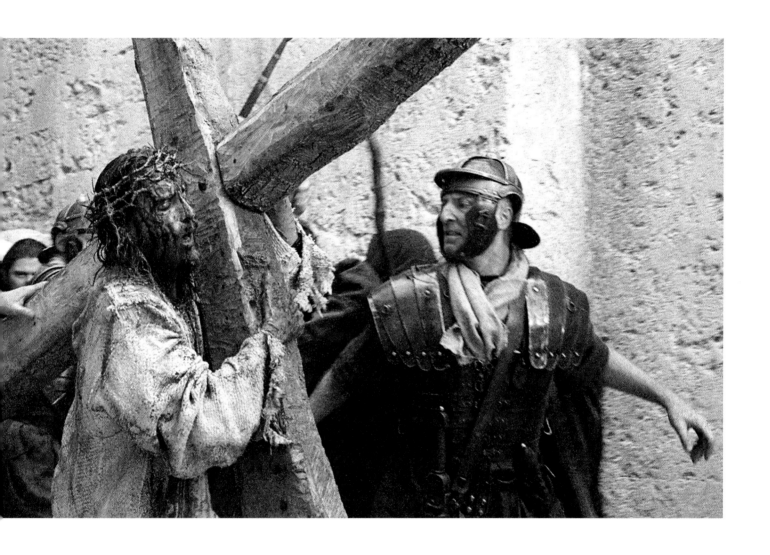

Despised, and the most abject of men, a man of sorrows,
and acquainted with infirmity: and his look was as it were
hidden and despised, whereupon we esteemed him not.

Isaias 53:3

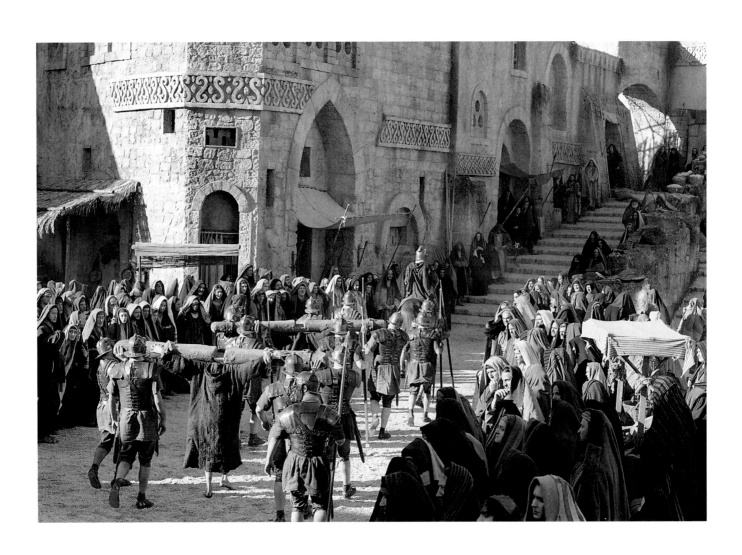

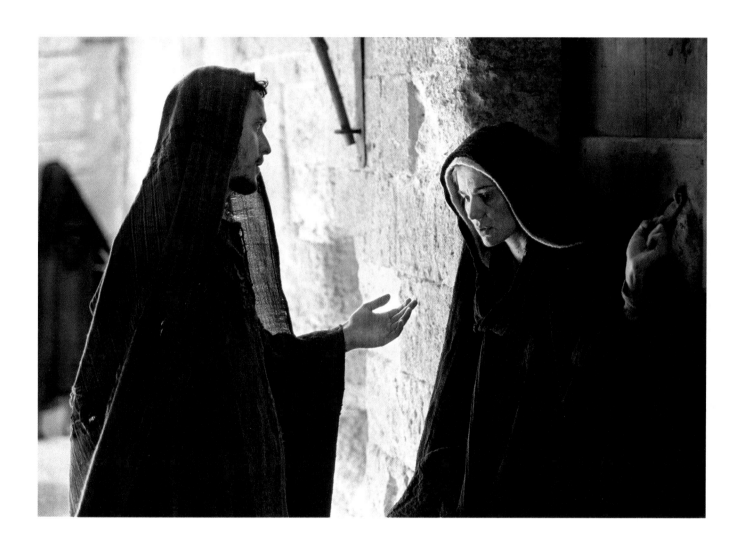

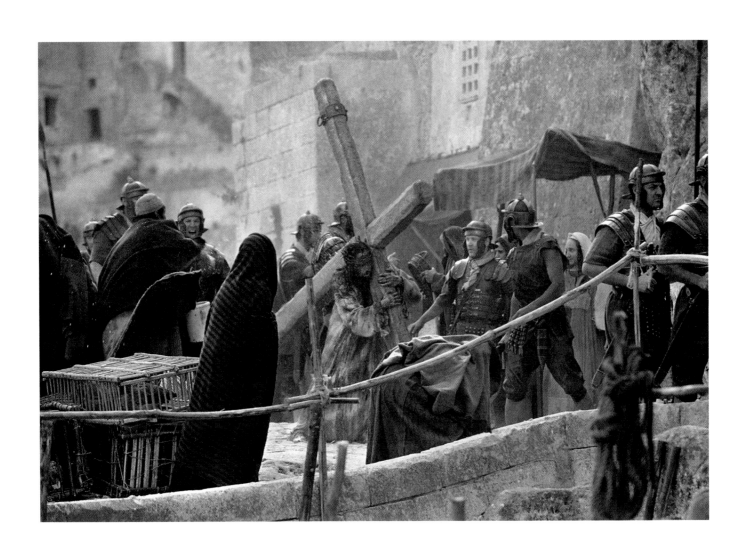

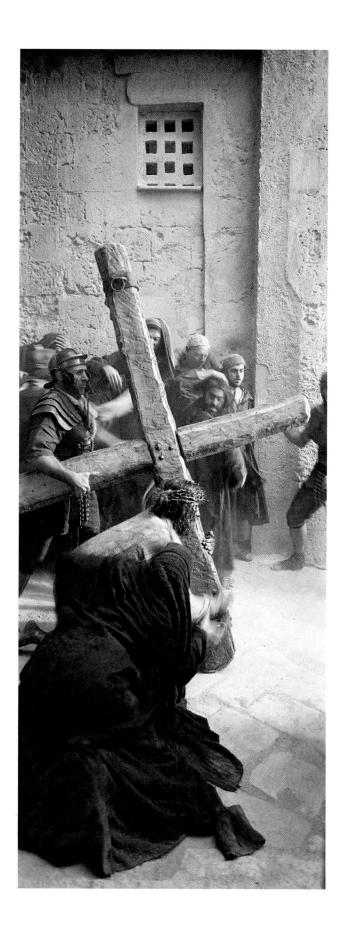

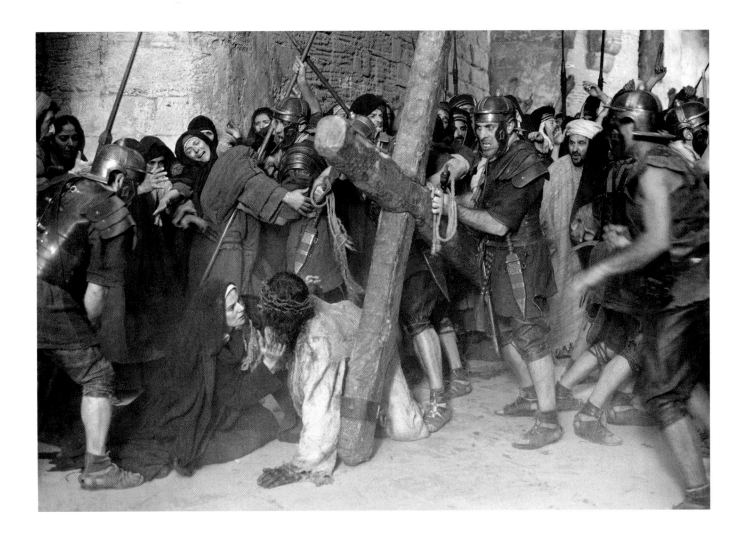

My Son.

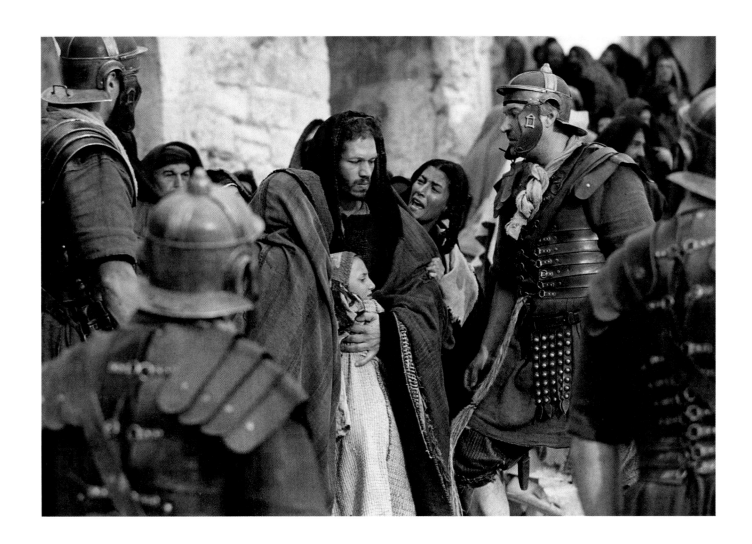

They laid hold of one Simon of Cyrene, and
they laid the cross on him to carry after Jesus.
Luke 23:26

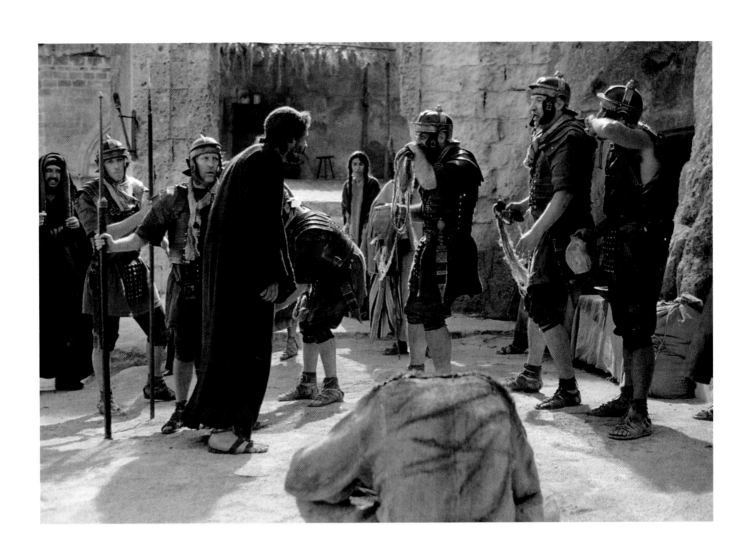

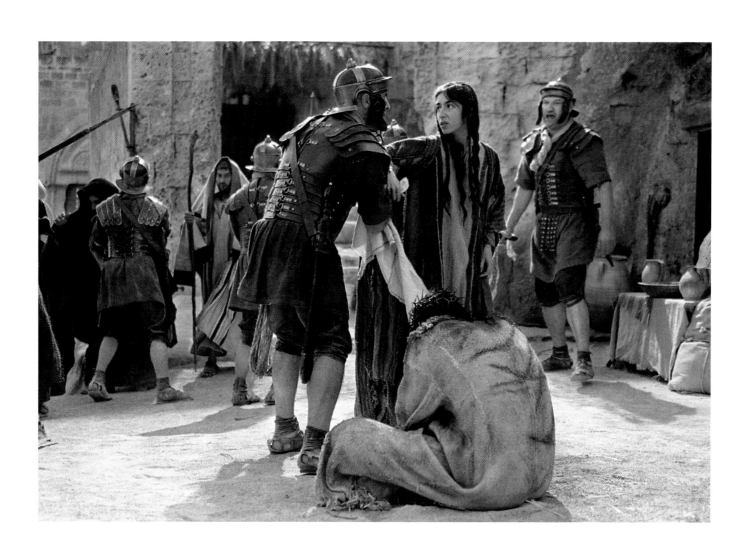

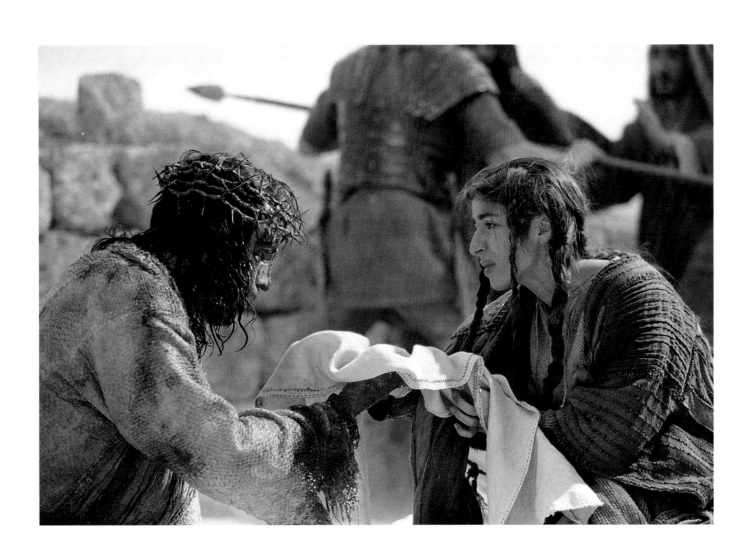

Veronica offers her veil to Jesus to wipe his face.

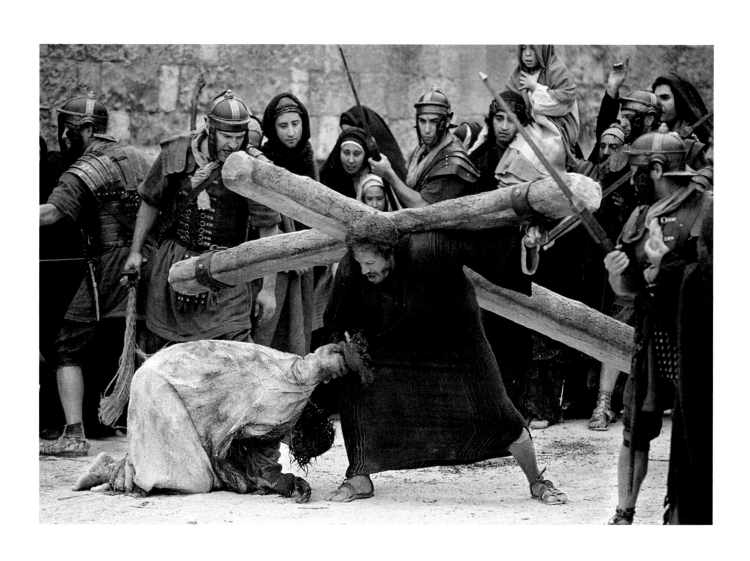

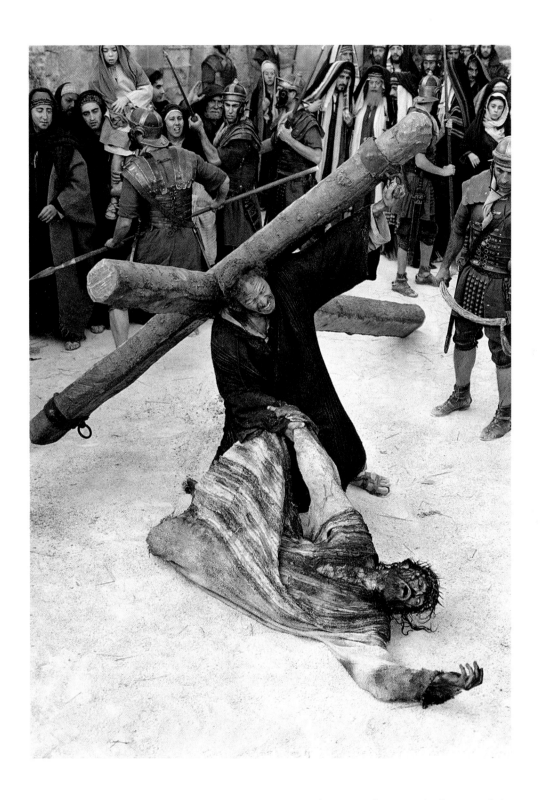

*But I am a worm, and no man: the reproach of men, and the
outcast of the people. All they that saw me have laughed me to scorn.*

Psalm 21(22):7–8

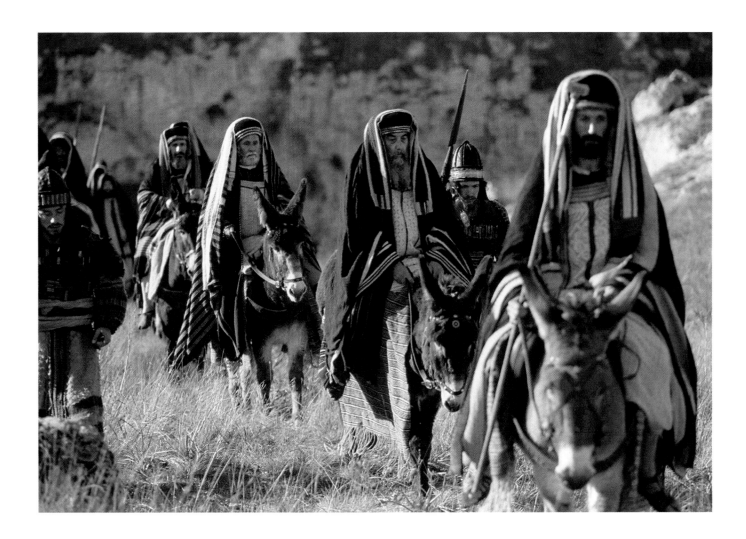

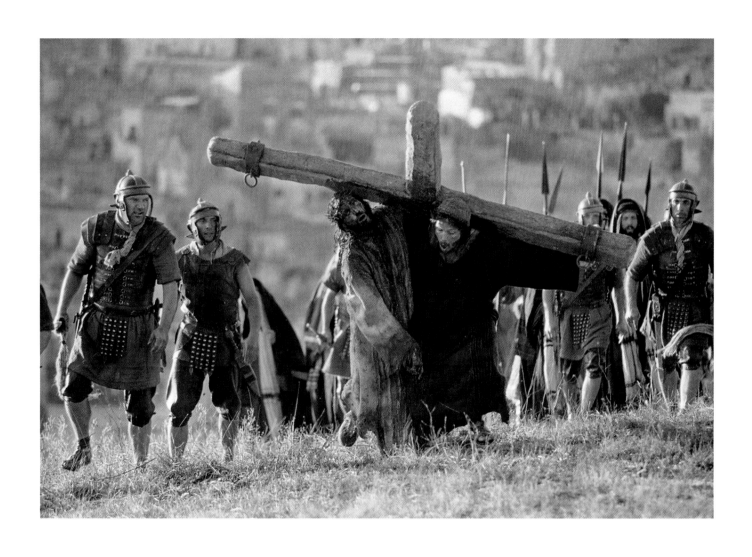

And they came to the place that is called
Golgotha, which is the place of Calvary.
Matthew 27:33

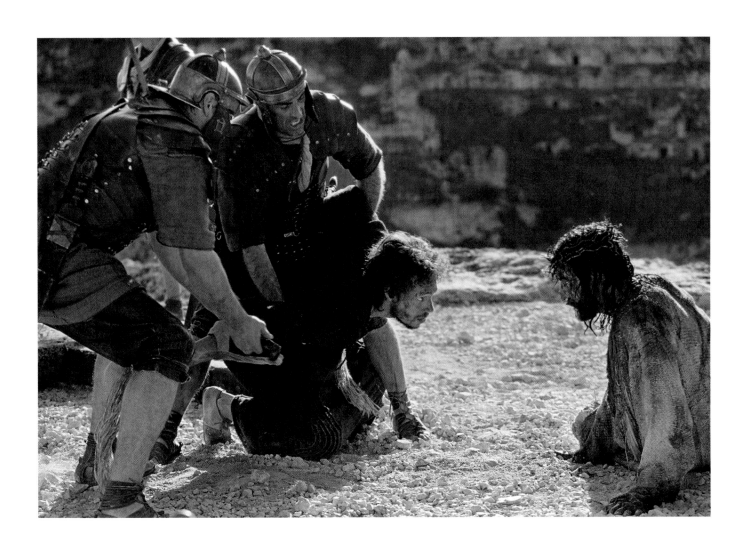

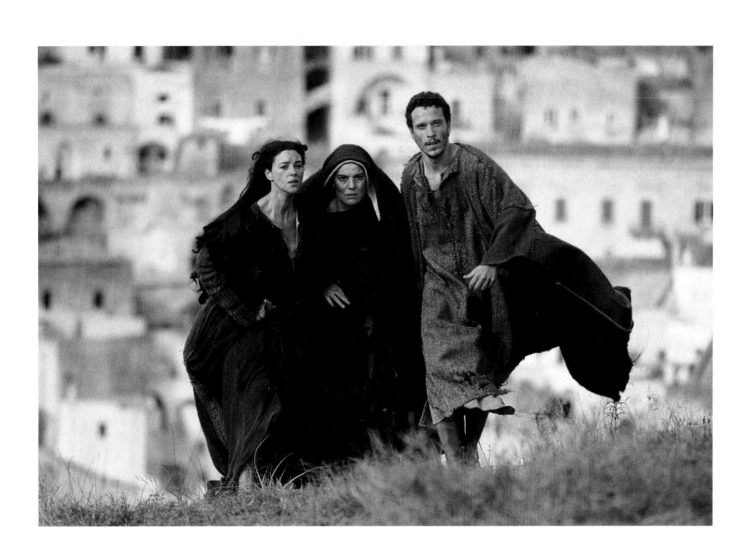

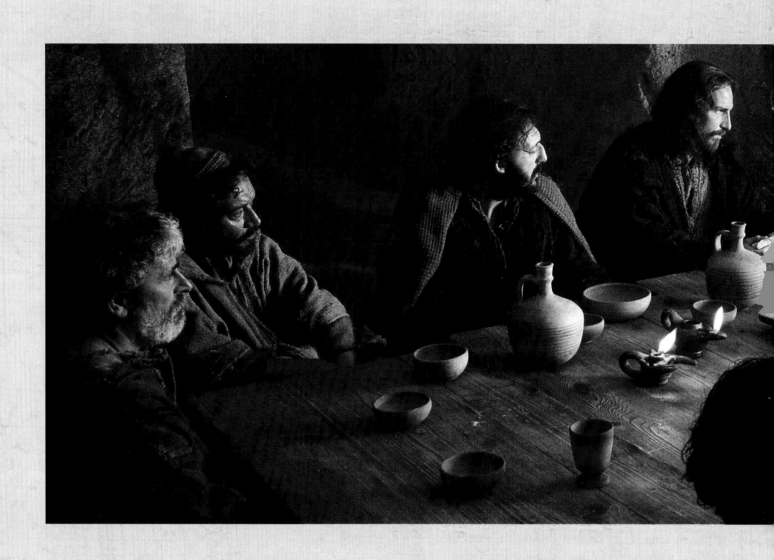

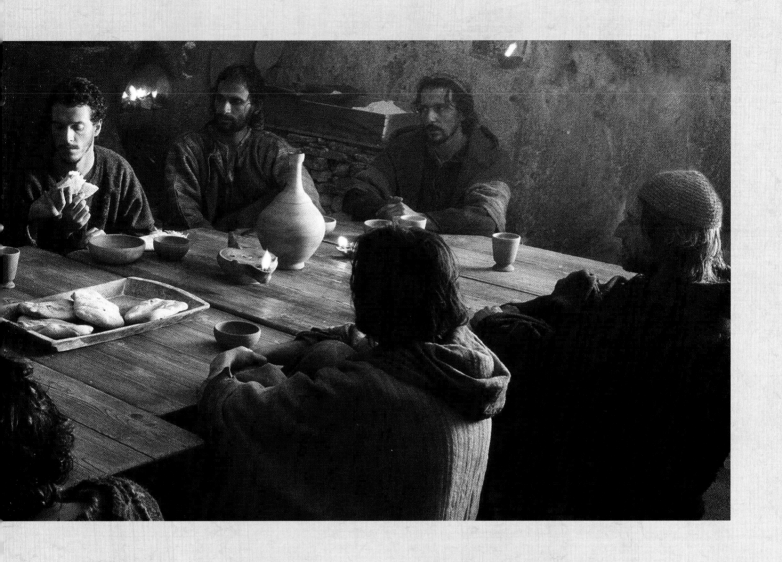

"With desire I have desired to eat this pasch with you, before I suffer."

Luke 22:15

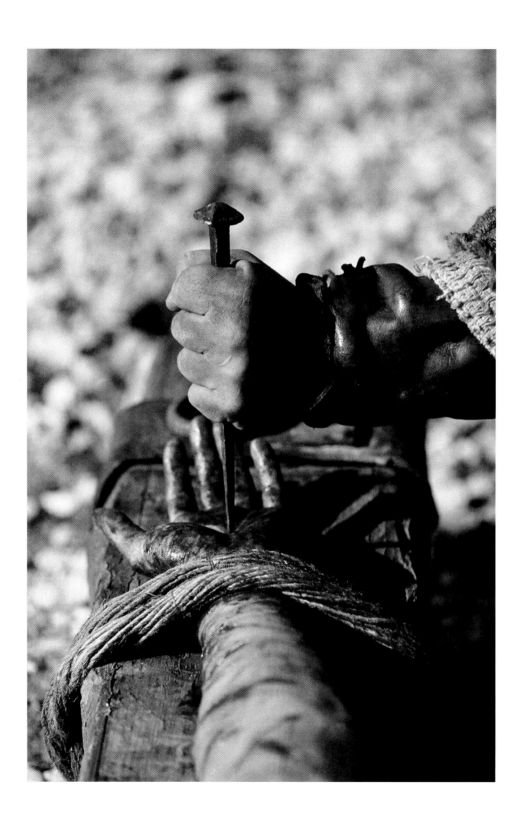

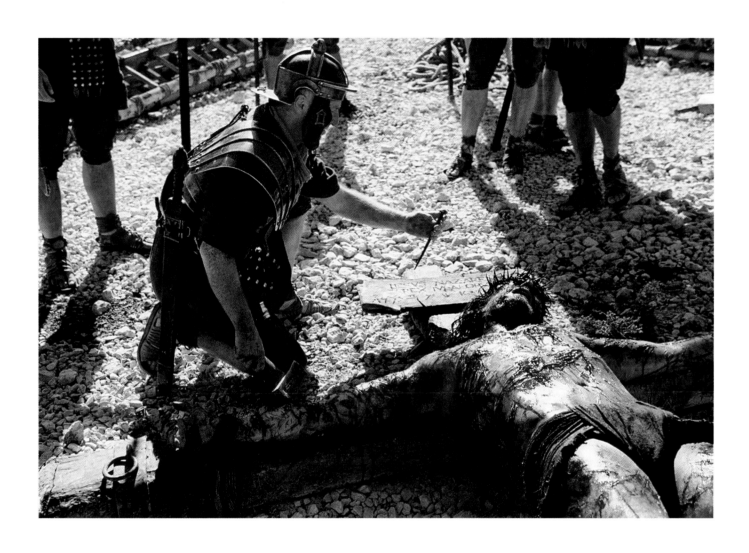

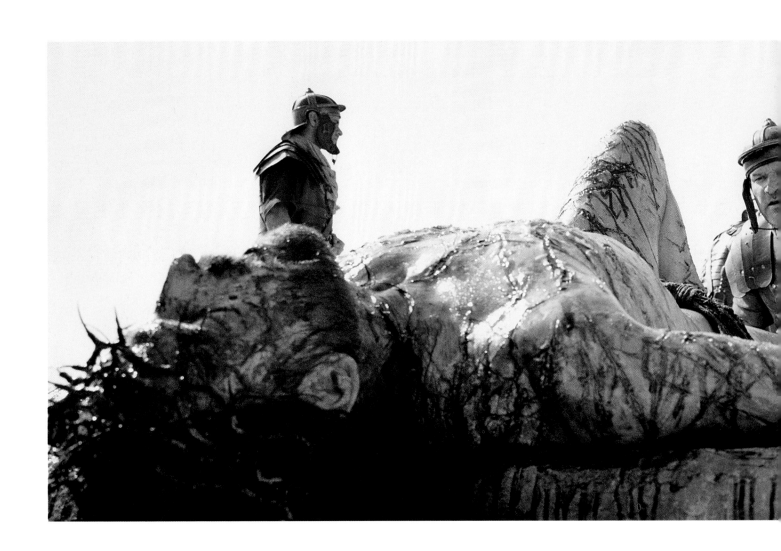

They have dug my hands and feet.

Psalm 21(22):17

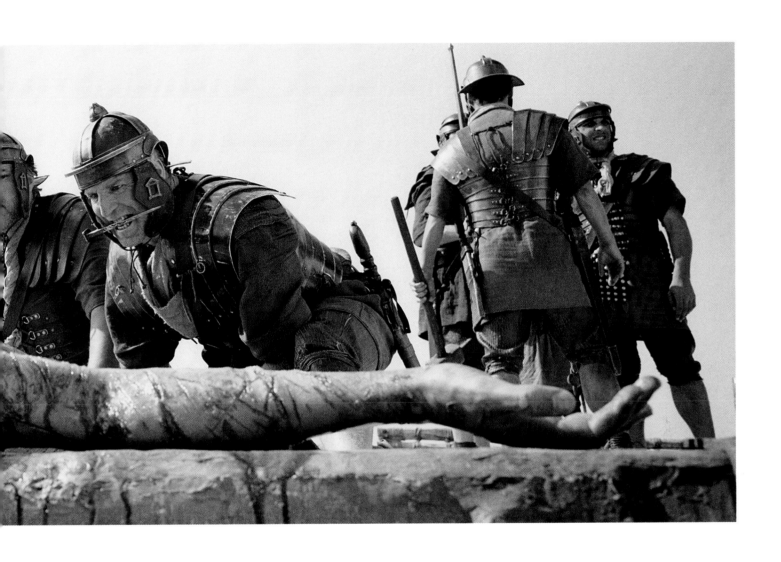

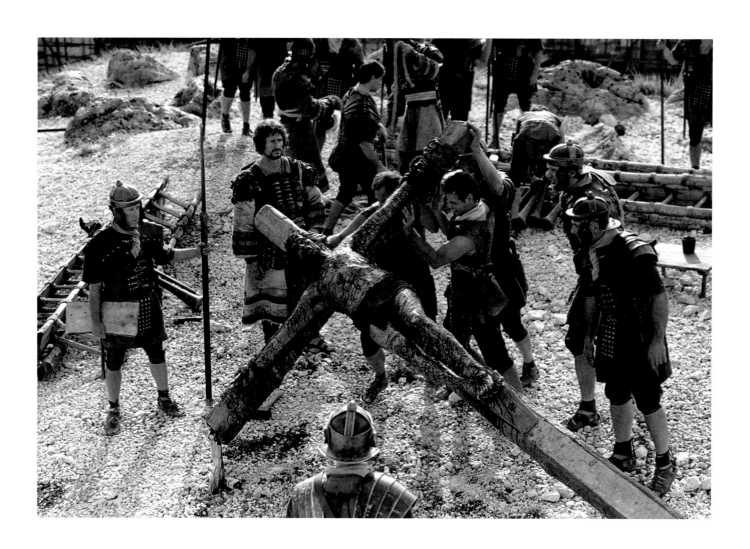

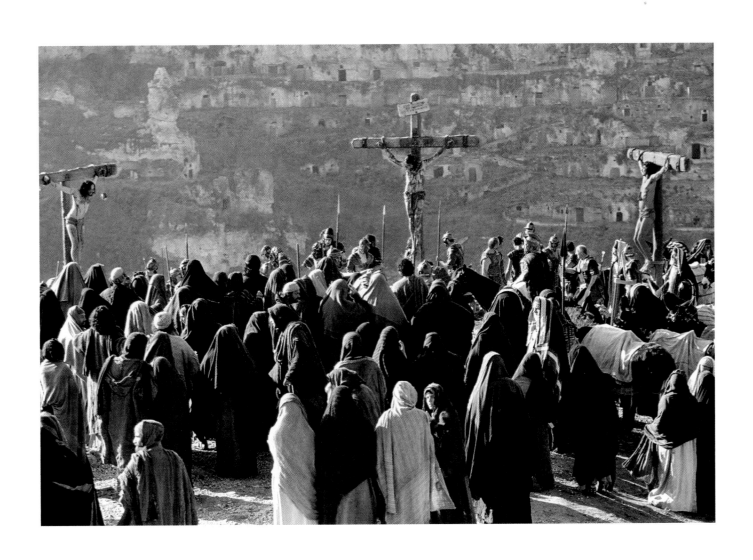

And there were also two other malefactors led with him to be put to death.
And when they were come to the place which is called Calvary, they crucified
him there; and the robbers, one on the right hand, and the other on the left.

Luke 23:32–33

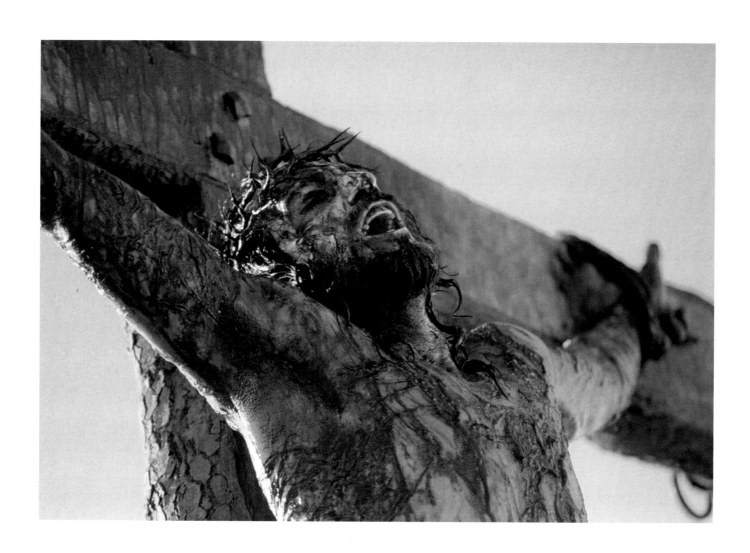

QABBILU LEH AKULU. DNA HU GISHMI.

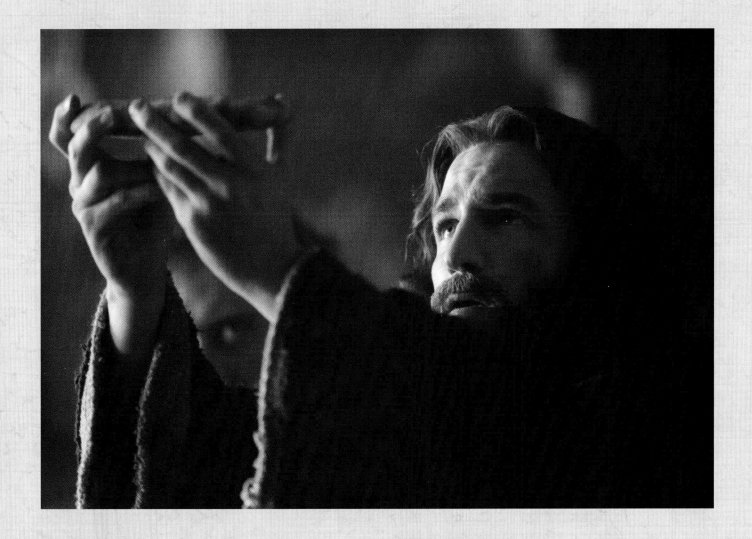

Take this and eat. This is my body.

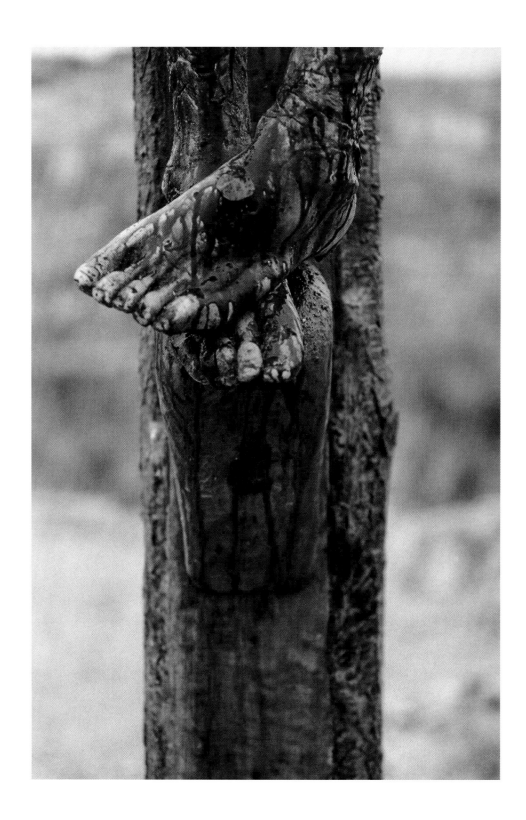

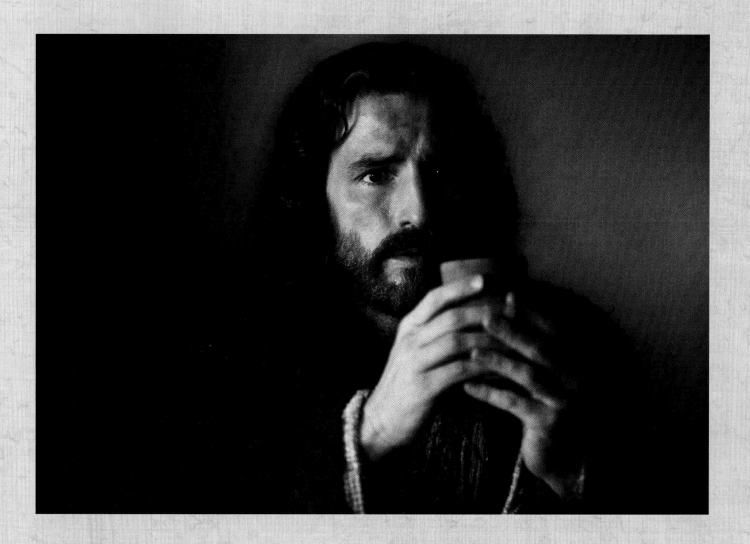

Take and drink. This is my blood.

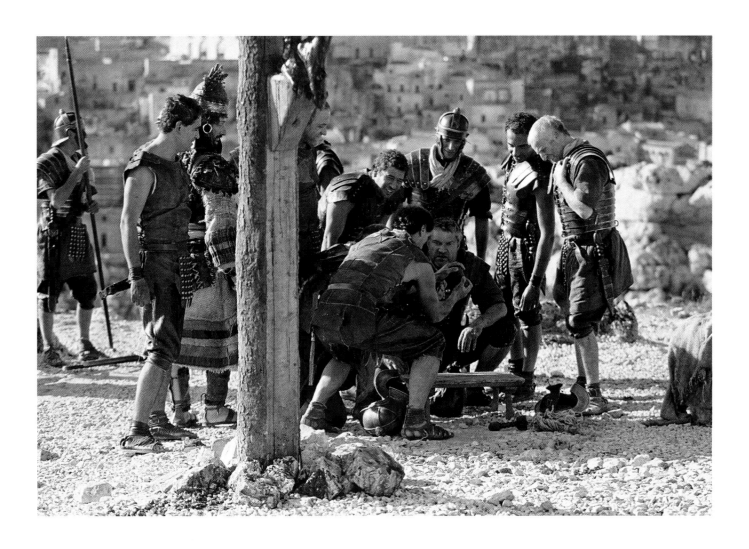

They parted my garments amongst them;
and upon my vesture they cast lots.

Psalm 21(22):19

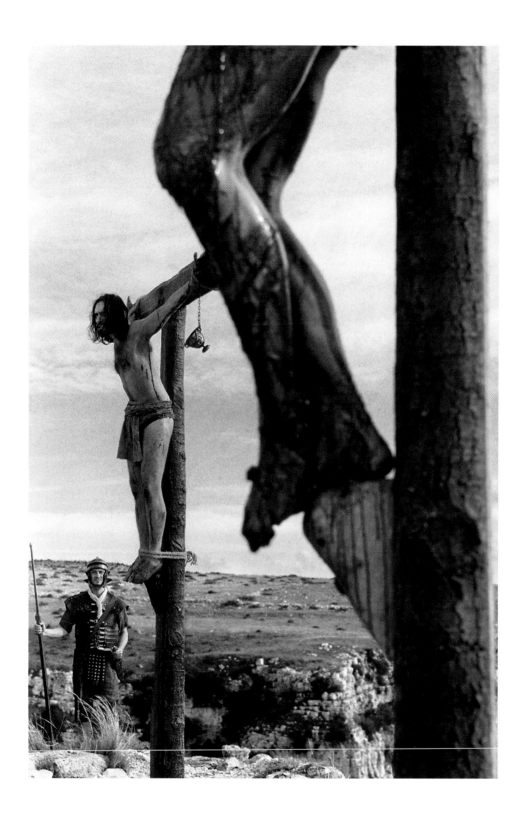

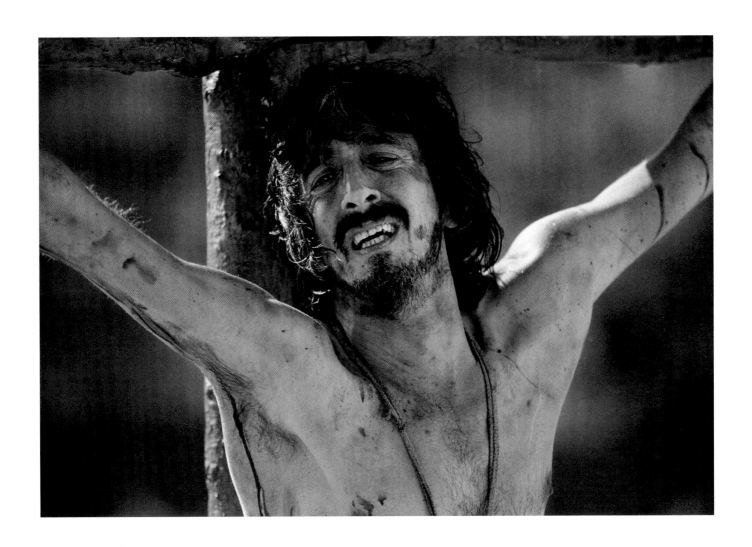

"Lord, remember me when thou shalt come into thy kingdom."

"Amen I say to thee, this day thou shalt be with me in paradise."

Luke 23:42–43

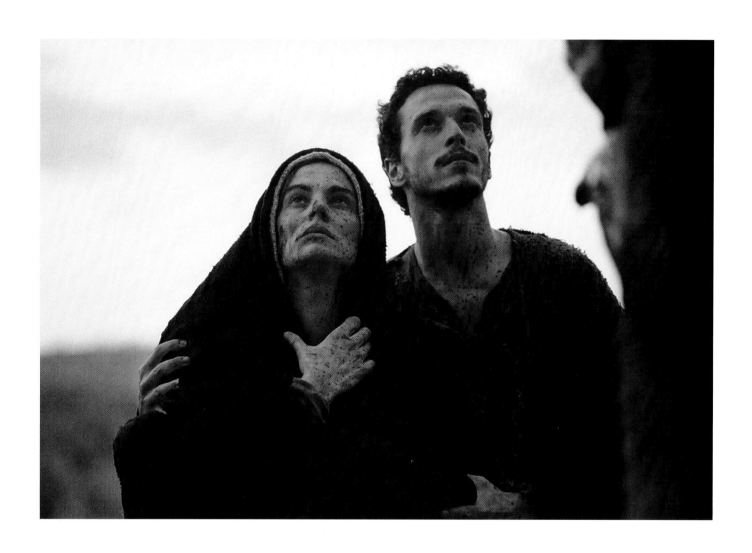

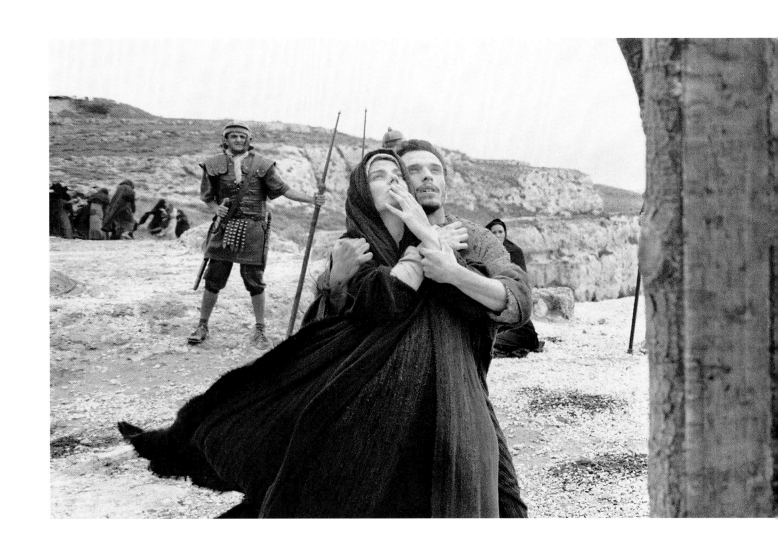

When Jesus therefore had seen his mother and the disciple standing whom he loved, he saith to his mother: "Woman, behold thy son." After that, he saith to the disciple: "Behold thy mother." And from that hour, the disciple took her to his own.

John 19:26–27

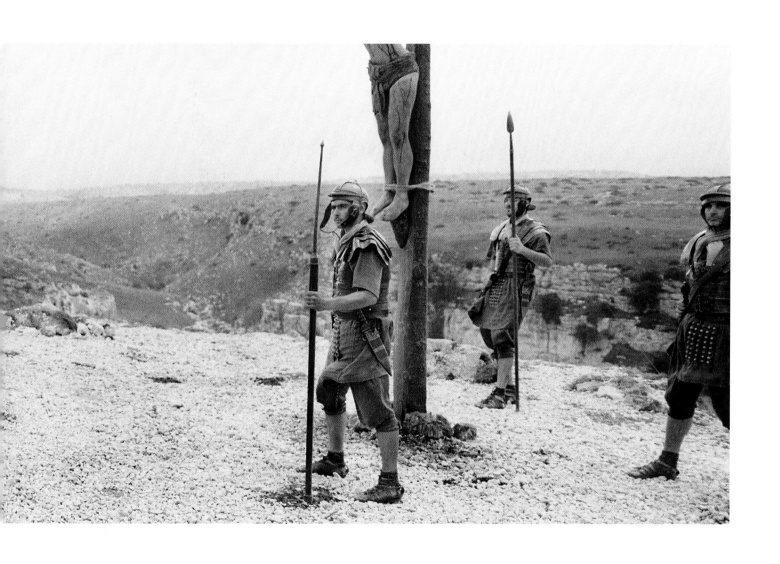

THE DEATH OF JESUS

And when the sixth hour was come, there was darkness over the whole earth until the ninth hour. And at the ninth hour, Jesus cried out with a loud voice, saying: "Eloi, Eloi, lamma sabacthani?" Which is, being interpreted, "My God, my God, why hast thou forsaken me?"

Afterwards, Jesus knowing that all things were now accomplished, that the scripture might be fulfilled, said: "I thirst." Now there was a vessel set there full of vinegar. And they, putting a sponge full of vinegar about hyssop, put it to his mouth. Jesus therefore, when he had taken the vinegar, said: "It is consummated." And bowing his head, he gave up the ghost.

And behold the veil of the temple was rent in two from the top even to the bottom, and the earth quaked, and the rocks were rent. And the graves were opened: and many bodies of the saints that had slept arose, and coming out of the tombs after his resurrection, came into the holy city, and appeared to many.

Now the centurion and they that were with him watching Jesus, having seen the earthquake and the things that were done, were sore afraid, saying: "Indeed this was the Son of God." And all the multitude of them that were come together to that sight, and saw the things that were done, returned striking their breasts.

And there were also women looking on afar off, among whom was Mary Magdalen, and Mary the mother of James the less and of Joseph, and Salome, who also when he was in Galilee followed him and ministered to him, and many other women that came up with him to Jerusalem.

Then the Jews (because it was the parasceve), that the bodies might not remain upon the cross on the sabbath day (for that was a great sabbath day), besought Pilate that their legs might be broken and that they might be taken away. The soldiers therefore came, and they broke the legs of the first and of the other that was crucified with him.

But after they were come to Jesus, when they saw that he was already dead, they did not break his legs. But one of the soldiers with a spear opened his side, and immediately there came out blood and water. For these things were done that the scripture might be fulfilled: *You shall not break a bone of him.* And again another scripture saith: *They shall look on him whom they pierced.*

Mark 15:33–34, 40–41; John 19:28–30, 31–34, 36–37; Matthew 27:51–54; Luke 23:48

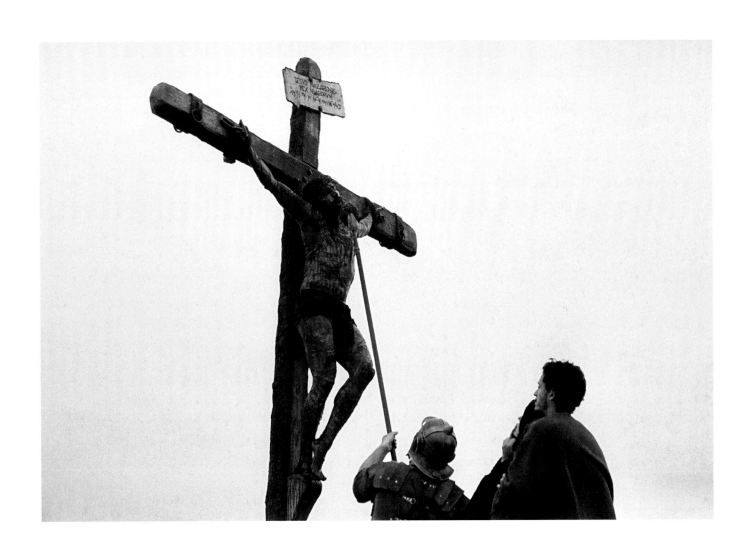

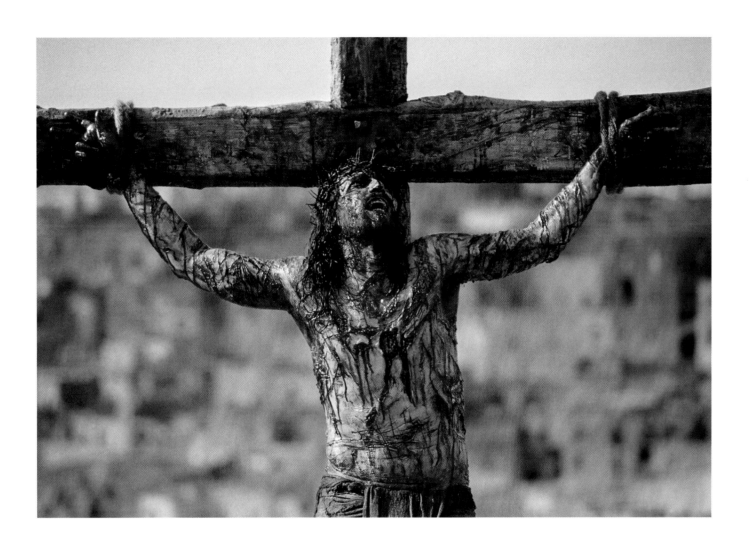

"My God, my God, why hast thou forsaken me?"

Mark 15:34

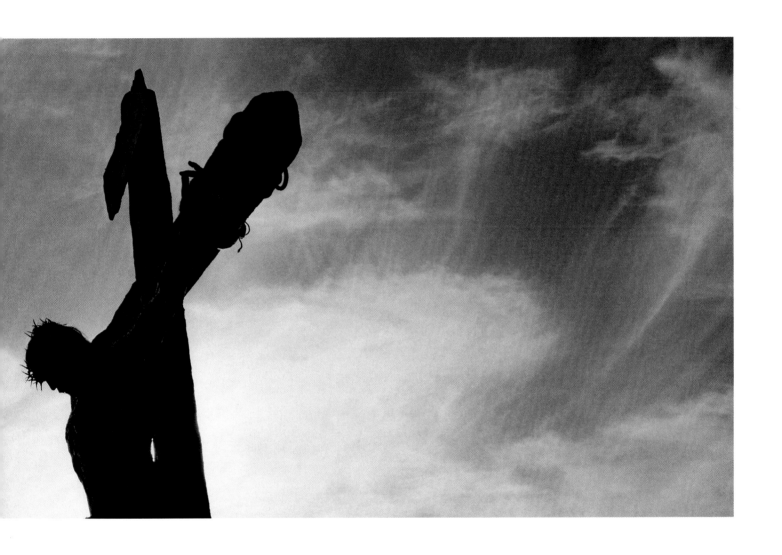

"It is consummated."

John 19:30

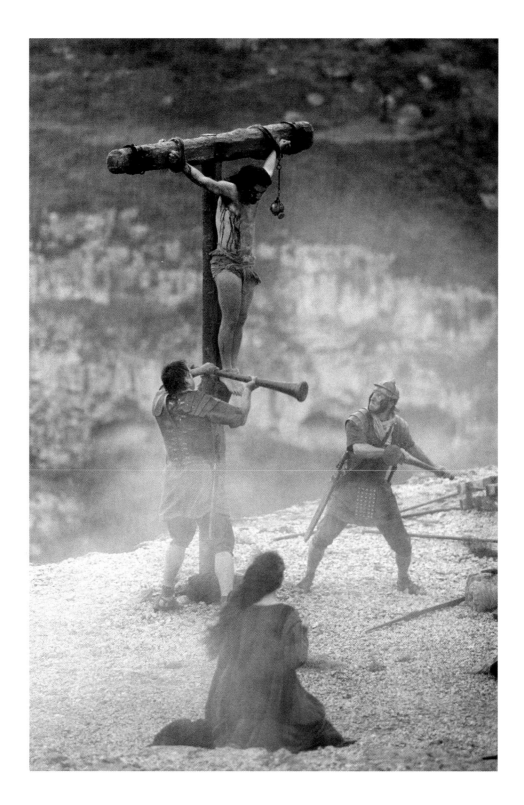

Then the Jews, that the bodies might not remain upon the cross on the sabbath day,
besought Pilate that their legs might be broken and that they might be taken away.

John 19:31

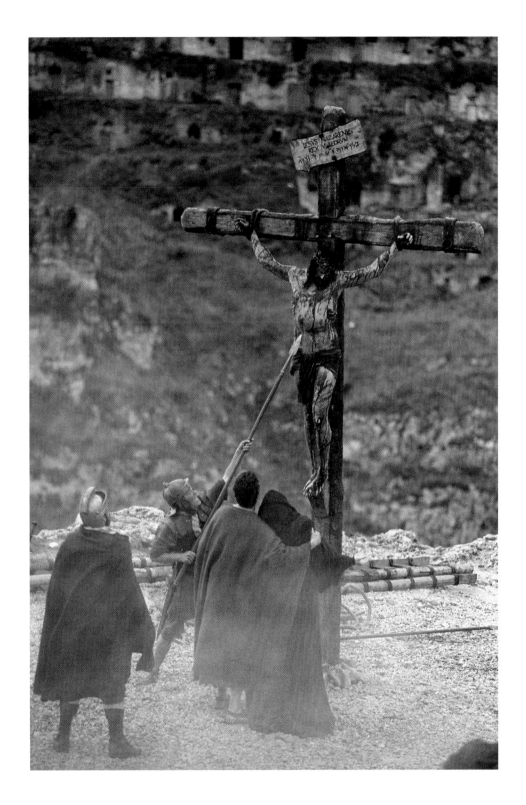

But one of the soldiers with a spear opened his side,
and immediately there came out blood and water.

John 19:34

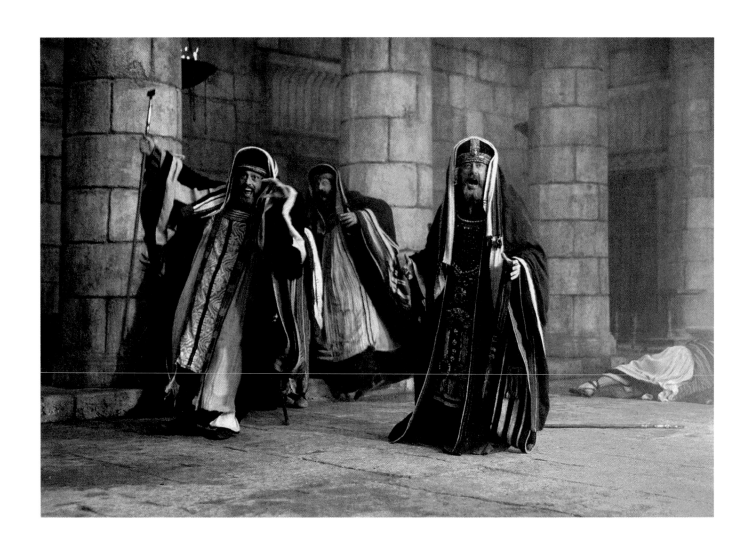

And behold the veil of the temple was rent in two from the top even to
the bottom, and the earth quaked, and the rocks were rent. And the
graves were opened, and many bodies of the saints that had slept arose.

Matthew 27:51–52

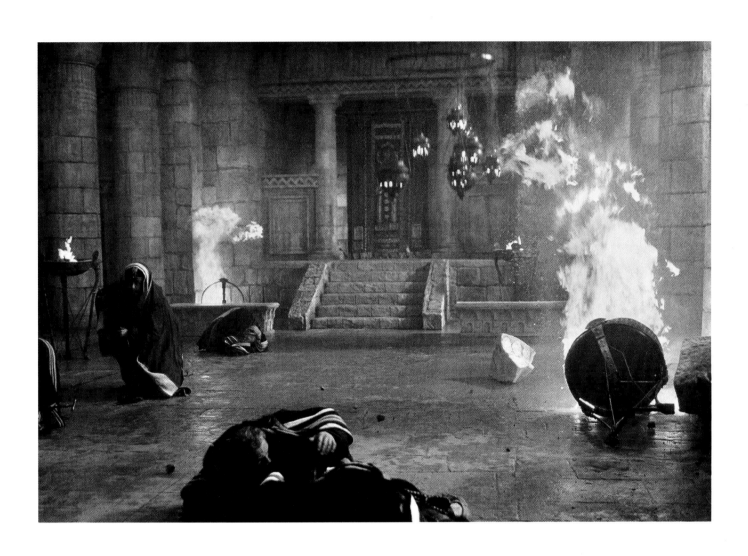

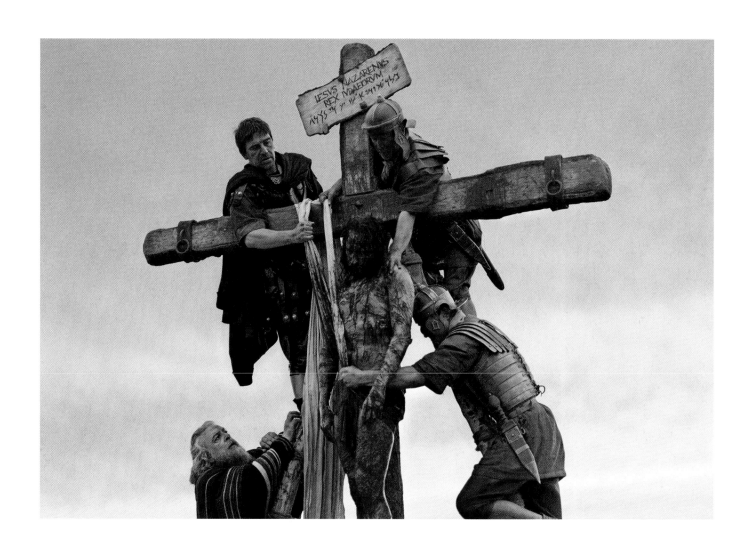

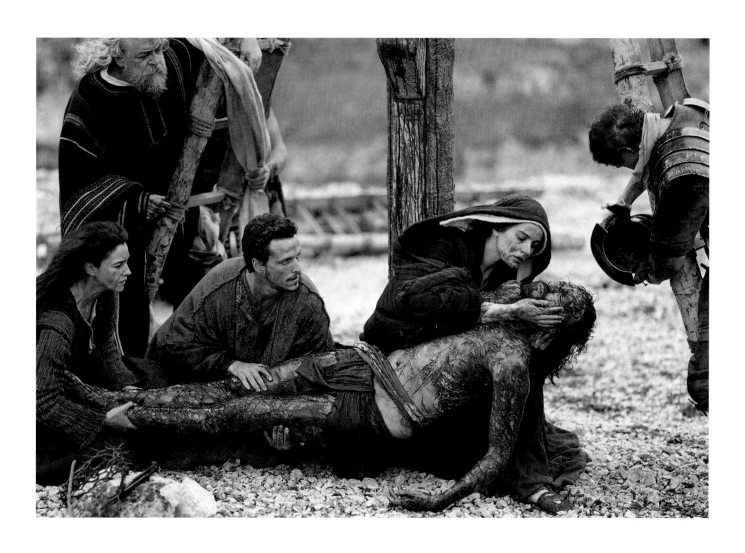

JESUS IS BURIED

And after these things, Joseph of Arimathea (because he was a disciple of Jesus, but secretly for fear of the Jews) besought Pilate that he might take away the body of Jesus. And Pilate gave leave. He came therefore, and took away the body of Jesus. And Nicodemus also came (he who at the first came to Jesus by night), bringing a mixture of myrrh and aloes, about a hundred pound weight. They took therefore the body of Jesus, and bound it in linen cloths, with the spices, as the manner of the Jews is to bury. Now there was in the place where he was crucified, a garden; and in the garden a new sepulchre, wherein no man yet had been laid. There, therefore, because of the parasceve of the Jews, they laid Jesus, because the sepulchre was nigh at hand.

THE RESURRECTION

And on the first day of the week, Mary Magdalen cometh early, when it was yet dark, unto the sepulchre; and she saw the stone taken away from the sepulchre. She ran, therefore, and cometh to Simon Peter, and to the other disciple whom Jesus loved, and saith to them: "They have taken away the Lord out of the sepulchre, and we know not where they have laid him."

Peter, therefore, went out, and that other disciple, and they came to the sepulchre. And they both ran together, and that other disciple did outrun Peter and came first to the sepulchre. And when he stooped down, he saw the linen cloths lying; but yet he went not in. Then cometh Simon Peter following him, and went into the sepulchre, and saw the linen cloths lying, and the napkin that had been about his head, not lying with the linen cloths, but apart, wrapped up into one place. Then that other disciple also went in, who came first to the sepulchre, and he saw, and believed. For as yet they knew not the scripture, that he must rise again from the dead.

John 19:38–42; John 20:1–9

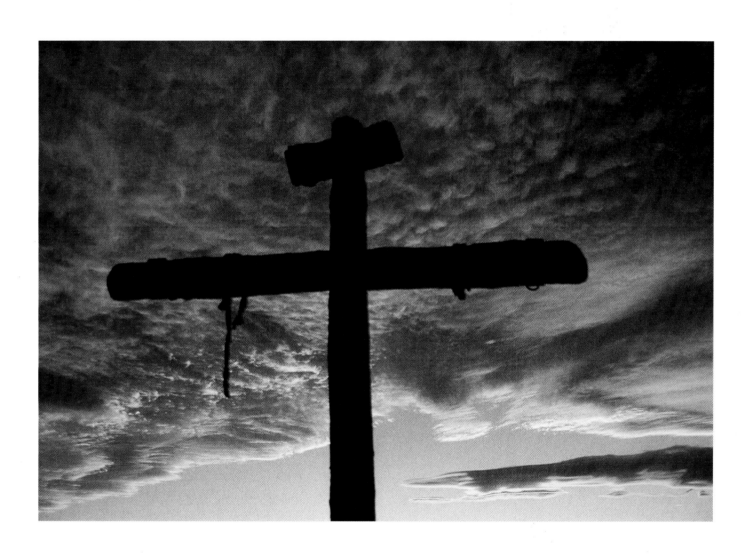

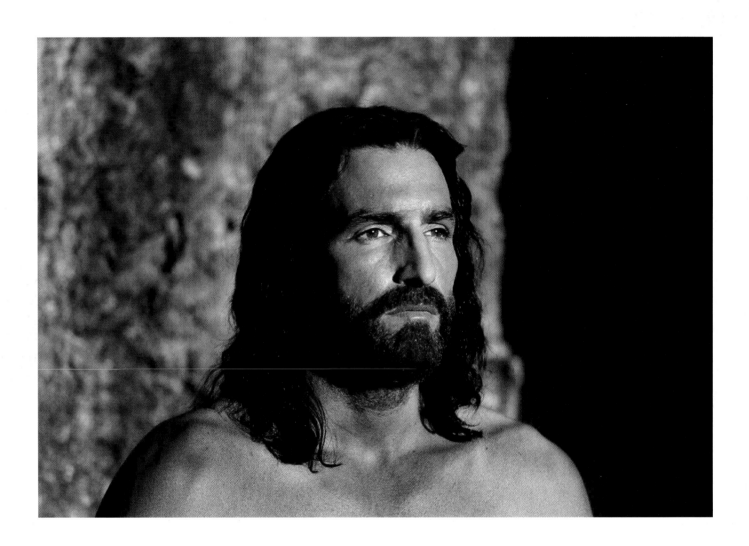

That which was from the beginning, which we have heard, which we have seen with
our eyes, which we have looked upon, and our hands have handled, of the word of life
. . . the life eternal, which was with the Father, and hath appeared to us.

1 John 1:1–2

THE FILMING

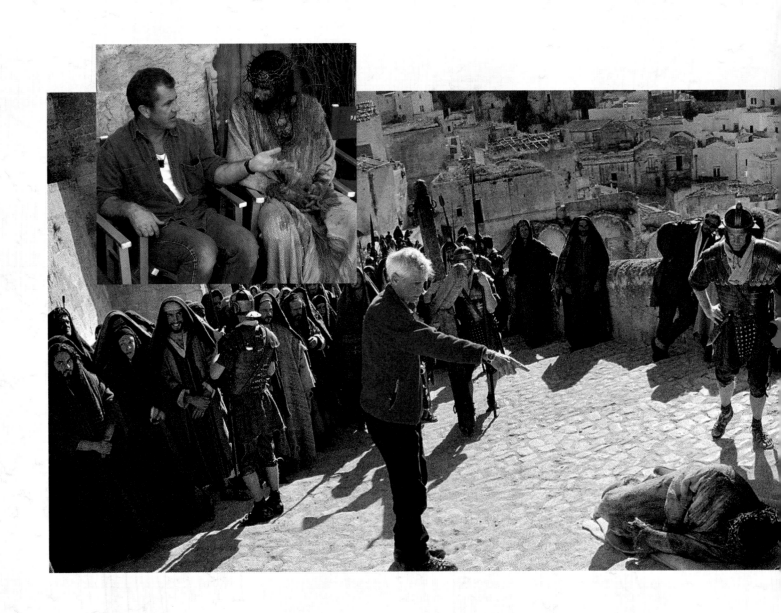

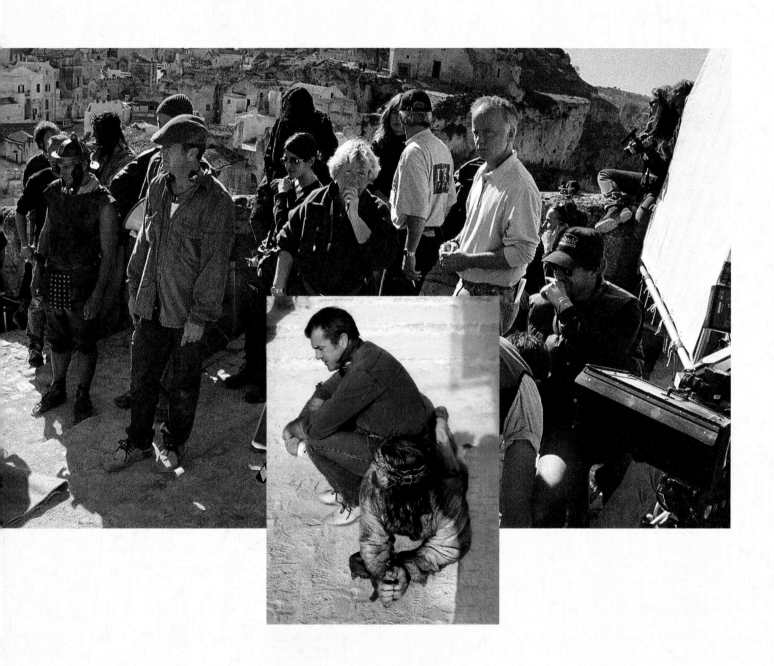

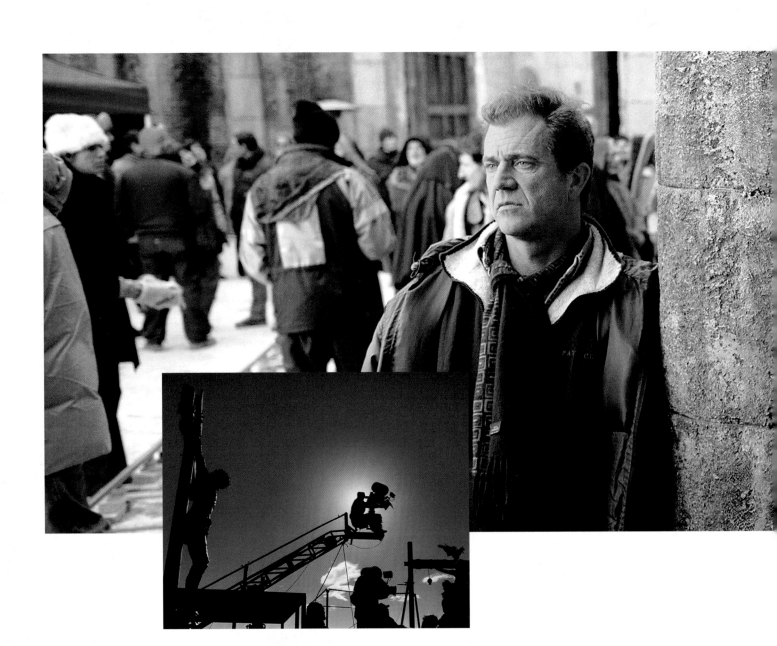

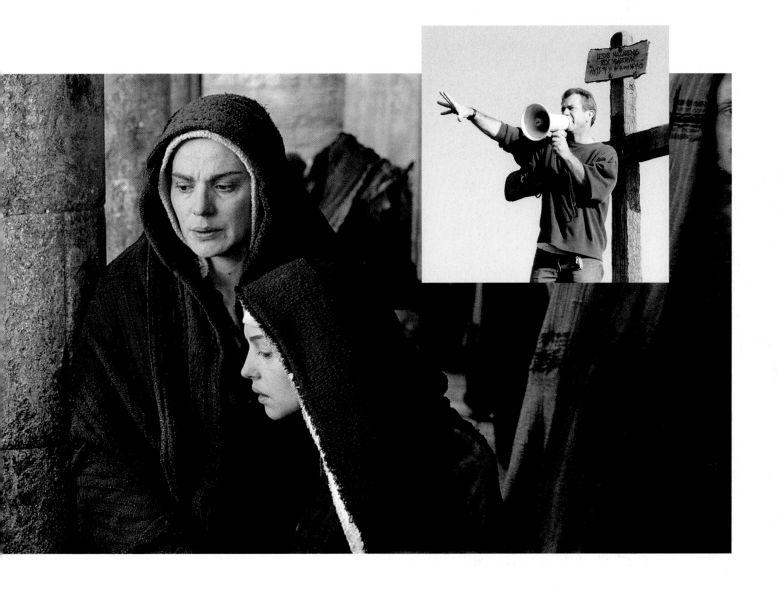

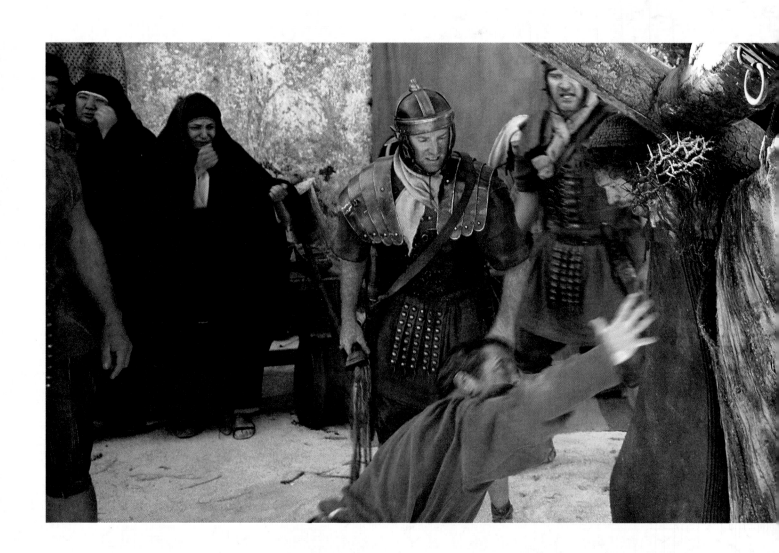